# AN EXPERIENCE OF MADNESS

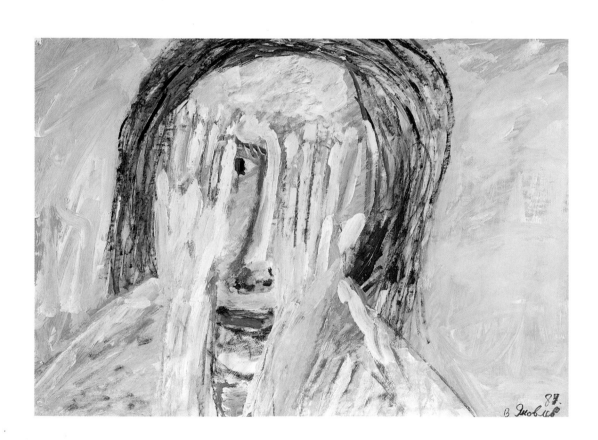

# AN EXPERIENCE OF MADNESS

## Alternative Russian Art

## in the 1960s–1990s

Natalia Tamruchi

CRAFTSMAN HOUSE

G+B ARTS INTERNATIONAL

Craftsman House wishes to acknowledge the assistance and co-operation
of Ludmila Makarova and her associates at Avtor Publishers, Moscow,
in the production of this book. The text and illustrations were compiled
by the staff of Avtor Publishers in conjunction with the author.

Distributed in Australia by Craftsman House,
20 Barcoo Street, Roseville East, NSW 2069
in association with G+B Arts International:
Australia, Austria, Belgium, China, France, Germany,
Hong Kong, India, Japan, Luxembourg, Malaysia,
Netherlands, Russia, Singapore, Switzerland,
United Kingdom, United States of America

ISBN 976 6410 49 6

Design    *Craftsman House*
Cover Design    *Caroline de Fries and Nichola Dyson Walker*
Printer    *Kyodo Printing Co., Singapore*

1. (Frontispiece)   Vladimir Yakovlev, *The Man Burying His Face in His Hands*, 1984,
Paper, gouache, 61 x 86 cm, Private collection, Moscow, Photograph: Valentin Chertok

# CONTENTS

'In the winter of 1982 I began to lose my senses and painstakingly noted down my emotions in the diary. Later, when I turned to patristic literature, the Taoist diagrams of "inner alchemistry", and the Sufic text *100 Stations* by Ansari, I was amazed to discover that except for some minor distinctions induced by [my] contemporary environment and the peculiarities of my psyche, my mind's change proceeded "according to plan", in compliance with most of the technological details mentioned in esoteric literature.

'I made several attempts to reduce the diary notes to a single text, but failed to do it, for I could not keep the distance from my self; the text appeared unhealthy, while the iconographic spaces that should have been the objects of the text manifestations were dimmed by irrelevant verbalisation. Finally it turned out that it was easier to materialise these spaces in an event, and this was done in a series of CA home actions.'

2. Vladimir Pyatnitsky, *Friday*, 1963, Paper, pencil, 28.5 x 20 cm, Collection: Nikolai Kotrelev, Moscow, Photograph: Valentin Chertok

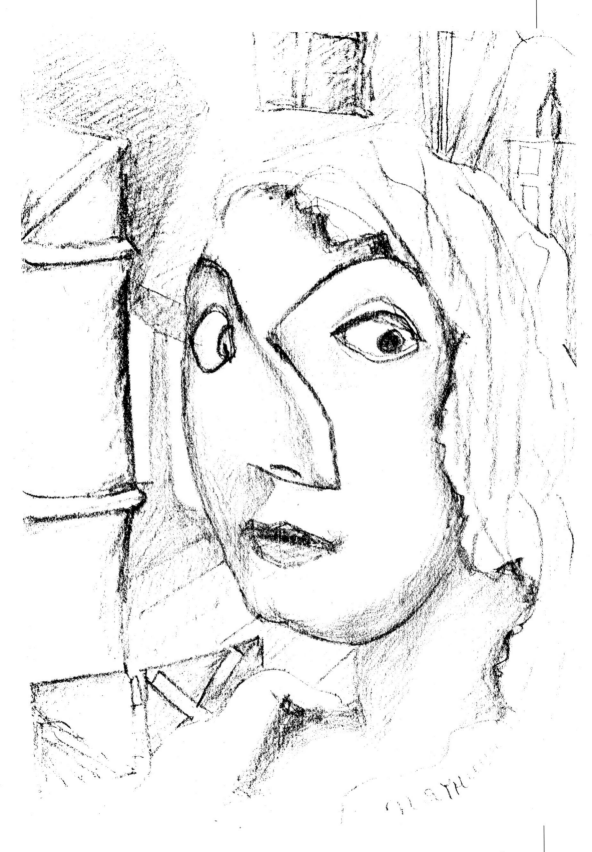

7

This curious confession was made by Andrei Monastyrsky, the leader and ideologist of the Moscow Collective Actions group. It is not a passage that was pulled out of the middle of the text; it is the beginning of the unpublished autobiographical novel *Kashirskoye Highway*. The very first phrase is somewhat confusing to the reader, who feels as if offered a journey in the space over an abyss. There is not the slightest hint of the circumstances that caused madness, none of the preliminary explanations usually provided by the mind when insanity is claimed. The reader has nothing to catch onto, nothing to which the natural question 'What happened?' could be tied. Why was the author losing his senses? Monastyrsky's text provides no answer; and not only that, it leaves no point at which to start inquiring.

3. Vladimir Kovenadsky, *Little Dragons' Play*, 1985, Gravure on paper, 23 x 15 cm, Collection: Kovenadsky family, Moscow, Photograph: Valentin Chertok

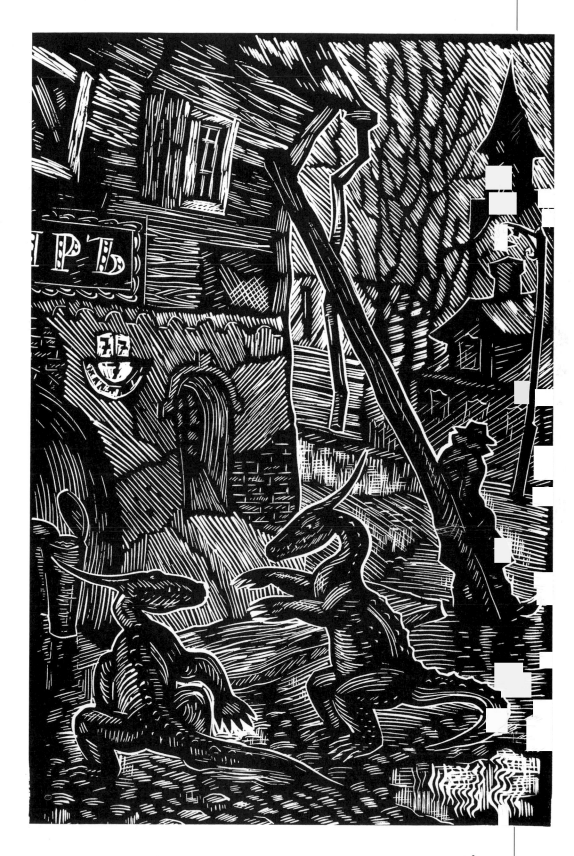

But can the mind understand madness without explaining its sources to itself? It is the causes of mental deformation that are real to the mind, and not the result of the deformation, for the latter is definitely outside the mind's competence. What else, besides the causes, can the mind refer to in order to justify madness? Yet, the author would not discuss the causes. Either he knows them only too well or, as is more likely, they are simply of no importance to him. That is why we discern a vague challenge in the opening phrase; something else is hidden behind it, some more audacious assertion, the thrust of which is that madness need not be justified, that it should be taken as it is, as a mental condition rather than as an irreversible mental disorder. Hence the author's imperturbability when he informs us of his insanity, comparable perhaps only with the imperturbability of a psychiatrist who has long stopped feeling either amusement or fear when observing madness — and this can be explained by his deep knowledge of the subject and the fact that this is an acquired habit.

4. Vladimir Kovenadsky, *Nightmare*, 1961, Gravure on paper, 12 x 17 cm, Collection: Kovenadsky family, Moscow, Photograph: Valentin Chertok

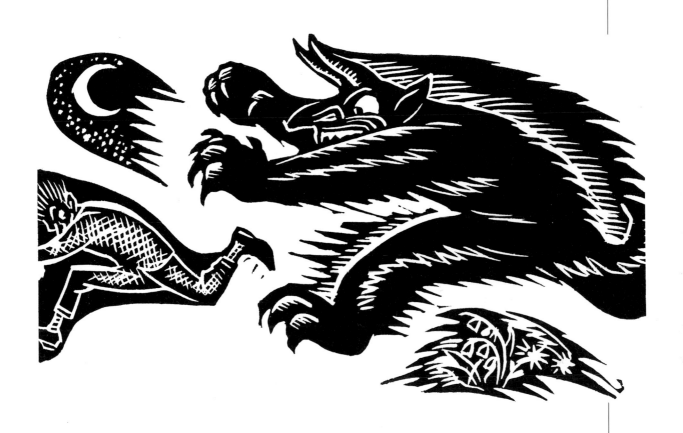

This analogy is not an arbitrary one. The culture from which Monastyrsky's text emerged, and to which it was addressed, was very familiar with this subject, long before the first line of the *Kashirskoye Highway* had been written. Afterwards this culture was named 'schizoid', and the appellation stuck, even when, as times changed, this culture altered its front beyond recognition, appearing under the guise of other styles and armed with new devices. In a word, this phenomenon existed from the 1960s, occasionally overflowing the limits of artistic tradition — in which case, art was more of a final result, or a plot design, while the plot itself unravelled in other mental spaces.

Obviously, there is no need to specify that schizoid culture was born in the Underground and that it once represented the deepest stratum of Soviet Underground art. Looking back, much of the then non-official art strikes us by its naivety, and the ban imposed on it by the authorities seems to be a mere historical lapse, which it is high time to forget. On

5. Vladimir Pyatnitsky, Untitled, 1960s, Paper, pencil, 28.5 x 20 cm, Collection: Nikolai Kotrelev, Moscow, Photograph: Valentin Chertok

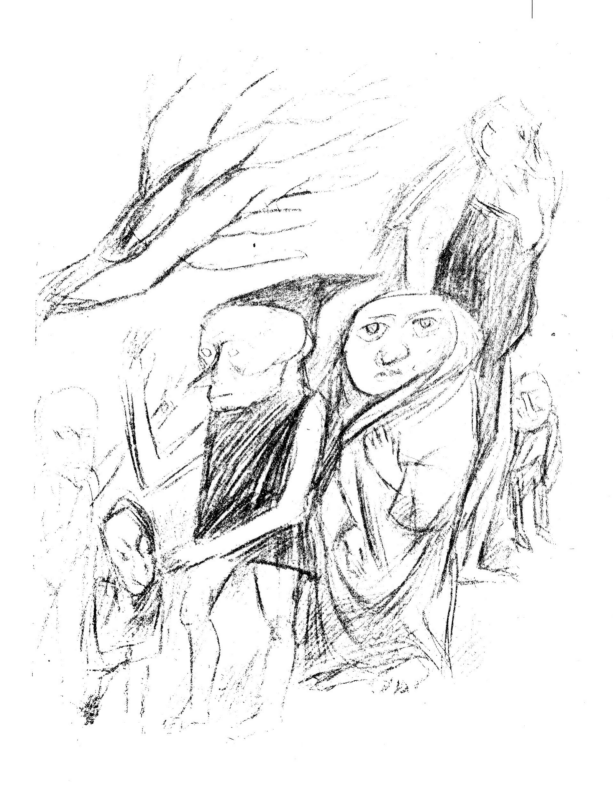

that occasion, however, fate chose correctly, creating precisely those conditions under which such a culture could arise. One would no doubt have to have been absolutely convinced that the Soviet State would never allow anything to be done that deviated from the established standard — even if only by a fraction, never allow a word to be uttered contrary to the official ideology that devoured both aesthetics and morality; one would probably have to have felt the futility of any actions carried out on the surface of life and, in addition, a strong antipathy for Soviet reality — in a word, one would have to have lost all confidence in the outer world in order to choose to counter its narrowness with the infinite inner resources one could reach, and to plunge passionately into a practical investigation of an area unable to be controlled or reached by the censorious eye of the State system — the area of psychic experience.

6. Vladimir Kovenadsky, Untitled, 1963, Gravure on paper, 15 x 10 cm, Collection: Kovenadsky family, Moscow

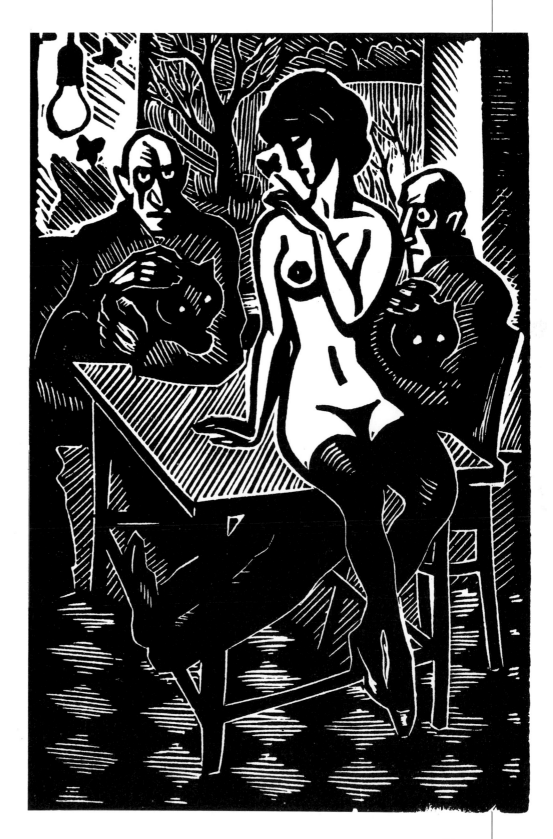

It should be said at the outset that this experience comprised not only various pathological states of the mind that assumed clinical form, but also any experiments that forced the mind to slide from the smooth surface of banal common sense to goodness knows where — perhaps to fall into the dark depths of the subconscious or to drift in the phantom worlds of narcotic hallucinations, or else to soar, thus gaining a mystic insight. If such lofty sensations amalgamated and intertwined, this might result, say, in a religious hallucinogenic psychosis, for, as Georges Bataille noted, a mystic's rapture is proportionate to their mental disorder. This is true, if we regard Monastyrsky's experience. (We shall return more than once to this word — disorder.)

The purpose or one of the purposes of such experiments was seen to be a complete freedom of consciousness. Nothing could keep it within the limits of a displeasingly crude reality any longer. And, most importantly, consciousness stopped obeying the laws of reality, and this could not but affect the style of relationships and the mode of life of those who created this culture.

7. Vladimir Pyatnitsky, *Fantasy*, 1971 (Detail), Paper, ink, pen, Private collection, Moscow, Photograph: Valentin Chertok

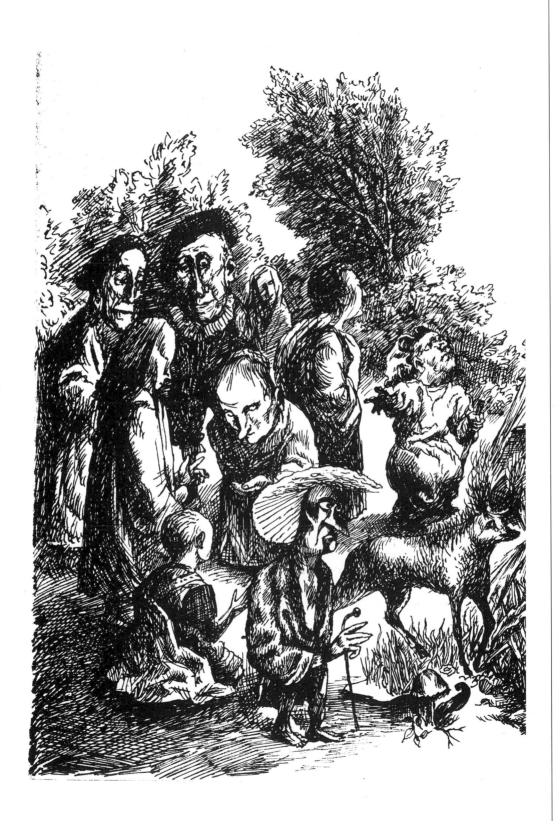

It is not possible to say definitely who these people were. Most of them were artists, but their paintings were not displayed; some were poets and writers whose works were not published at that time; others did not do anything in particular, but they had 'ideas' that burned their minds. They did not set up a society; it was more of a community, a circle of the initiated, who despised society as such and haughtily rejected its conventionalities, since conventionalities and interdictions were meant for the primitives. Any kind of behaviour was accepted there; in fact, strangeness was seen as a merit and was considered to be an inalienable feature of personality. Any action that was out of the ordinary was welcomed, for anyone in that milieu was given complete freedom to stage experiments on their self, life, and even death. They believed that the game was not worth playing unless all the cards had been dealt. Since everyday reality was, as always, greedy and stolid and offered them a scant set of moves, they had to invent more and more new combinations themselves, with a clear understanding that they were starting an entirely new game, the rules of which nobody knew. True, the risk was high, but that only served to intensify the reckless desire to try everything, to savour unusual sensations, to feel the pungency of

8. Vladimir Pyatnitsky, *Fantasy*
(Detail)

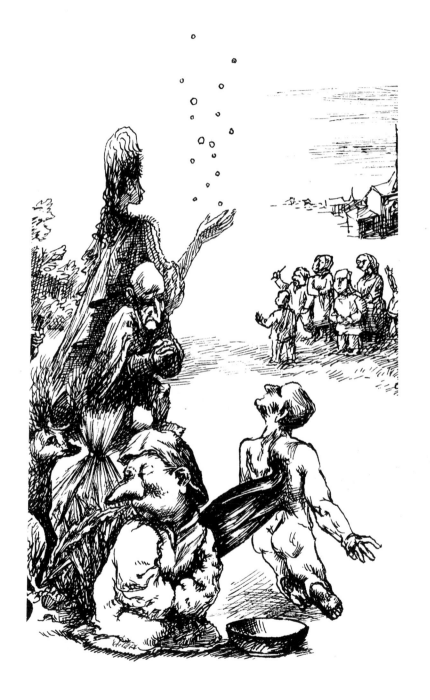

outrageous situations — if only for the sake of the intoxicating sense of being superior to a grey prosiness. It should be said that these games were rather fantastic, even cruel at times, and ended unhappily for some and tragically for others. But could they act otherwise if the latent potentials of self invoked an irresistible, morbid curiosity and the overwhelming temptation to find out whether there was a limit to them, and if so, when it was reached?

It is significant that these people understood each other and imbibed every grain of experience, their own and others', and united it into a single whole. It is impossible to overestimate their mutual influence, although they rarely imitated each other: they were saved from this by their individual peculiarities and the sense of personal uniqueness they cultivated. One can imagine the intensity of intercourse in this milieu, considering that their energy, talents and ambitions were manifested only in their own narrow circle, for it was unsafe and senseless to reveal them elsewhere.

9. Vladimir Pyatnitsky, *Tuesday*, 1963, Paper, pen, 28.5 x 20 cm, Private collection, Moscow, Photograph: Valentin Chertok

Any conceived idea was immediately unbosomed to others, for it was the only way to publicise it, to turn it into a fact of one's own consciousness and of culture. All thoughts were verbalised, ideas could actually be felt in the air, congesting it to the utmost and infecting one with morbidness and a kind of frenzy — not all could stand that atmosphere without losing their sanity.

Intercourse was what mattered most. Life was spent on it, it engulfed and spanned the people, driving them from one home to another and further along the charted route as far as there was strength to keep on one's legs. That culture's maniacal self-search could not perhaps be more clearly expressed in any way but in this endless movement, circulation and itinerancy. It seemed that culture itself was present wherever they, its bearers, gathered; this had to be the case. Their rambling sessions over a glass of vodka, to the accompaniment of verses and 'macabre' songs, their strange relationships and the

10. Yevgeny Chubarov, From the 'Soldiering' series, 1970s, Paper, charcoal, 24 x 31 cm, Collection: Lev Melikhov, Moscow, Photograph: Lev Melikhov

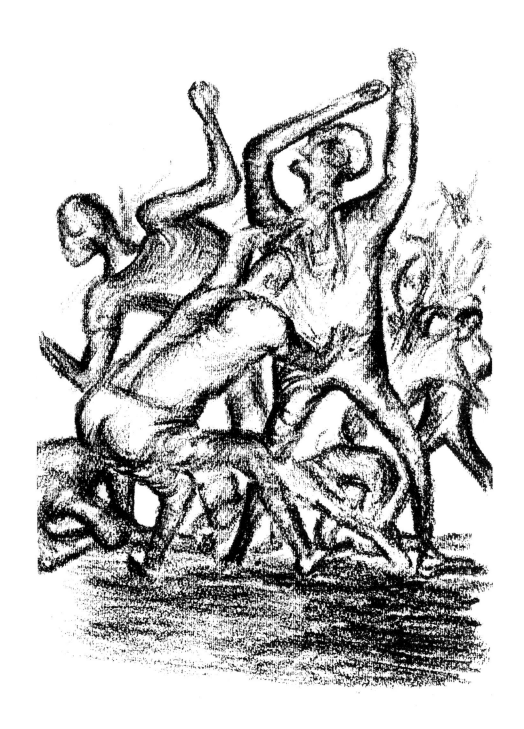

constant need they had for each other made up the substance of that culture, which was as tangible as it was ephemeral. It was destined to be born crippled: there was no intermediate section to divide physiology and spirit, and the latter inosculated so firmly that it would be hopeless to discern and separate them in the works of art left by that culture. That is why we can only observe the manifestations of the schizoid culture of the 1960s and 1970s, but we shall not hear a single sober word uttered by it in those years; we shall not detect any signs of self-reflection — at that time it was capable of nothing more than living in itself. As it happens, the first descriptions of Underground art appeared much later, during the 1980s, when it already had its history. The earlier epoch was too young to produce analytical texts, culturological concepts and philosophical generalisations. It was a period of unceasing debates, of the live exchange of words and ideas that wandered hand-in-hand with the people, the period of word-of-mouth information that spread, like an influenza epidemic, through personal contacts. We can surmise that many of the philosophical doctrines and systems were learned not from

11. Vladimir Pyatnitsky, *Vampires*, 1960s, 20 x 28.5 cm, Paper, ink, Collection: Nikolai Kotrelev, Moscow, Photograph: Valentin Chertok

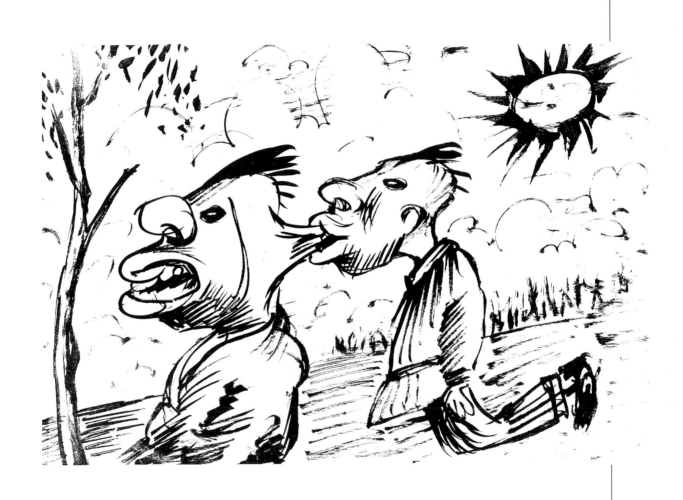

books but through hearsay, in the authorised interpretation of those who had read something or heard it from other people. Even literary works were immediately read out to the writer's friends, as if his or her writings would then be established in culture in an oral form. It was customary to come to listen to the poets and all kinds of writers as well. There were many places in Moscow where recitations were arranged for the public. Yuzhinsky Lane went down in history as the famous abode of the 'schizoids', where Yuri Mamleyev, the Underground writer and, in a sense, father of this tradition, lived and reigned.

An extremely diverse public came, from Underground artists and poets, homebred philosophers and occultists to pathological characters of all sorts who intensified the atmosphere of excitation cultivated there. As legend has it, the performance was set up in the following manner: the room was lit by a single lamp placed on the floor under a torn armchair in which the host presided — surrounded by his strange retinue. Caressing a human shin bone, he read his stories about vampires and necrophiles. One may ask where

12. Yevgeny Yufit, A shot from the film *Dad, Santa Claus is Dead*, 1991

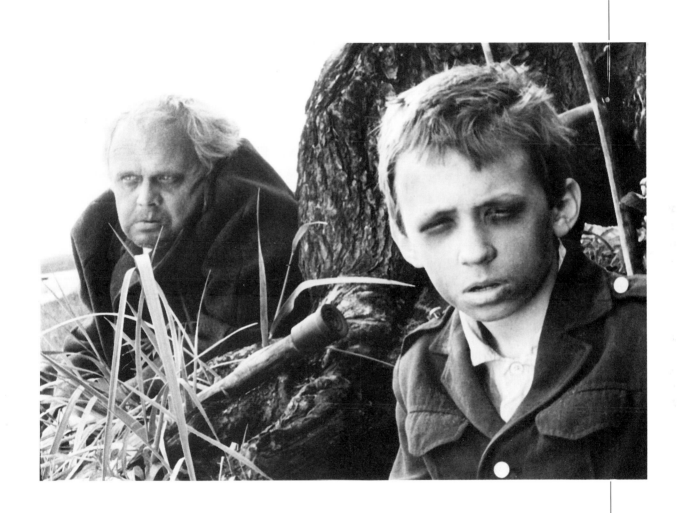

the difference lay, in such a situation, between the story that was read by the author and the spontaneous improvisation, performance and dialogue of the same people in the same setting. Any such situation could become a similar cultural event that would be remembered and retold with new details added. It was not a piece of creative work that was presented to the audience; the author presented himself. Perhaps it was unimportant in what form he did it.

At this point it might be thought appropriate to start a banal discourse on the elimination of the borders between art and life and on the transformation of real people into walking personages, but the reader should already have gained some sense of this. What is more unusual is that nobody tried to assume a contrived image. There was a stronger temptation: the possibility to manipulate 'live material', so to speak, making the human psyche an instrument of creative fantasies. This meant that fantasy no longer created its cold worlds all by itself — as with the Surrealists — revealing to the individual its

13. Yevgeny Yufit, A shot from the film *Dad, Santa Claus is Dead*, 1991

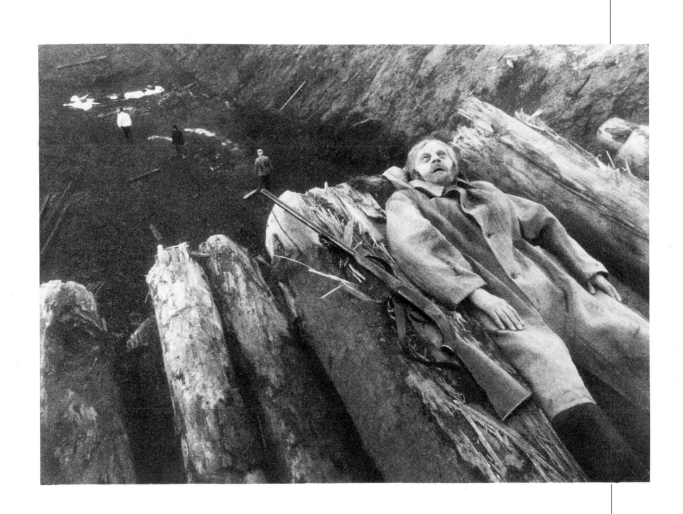

14. Yevgeny Yufit, A shot from the film *Dad, Santa Claus is Dead*, 1991

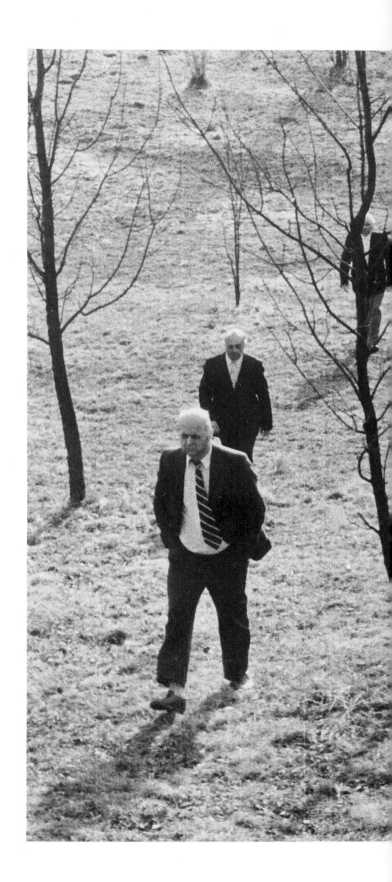

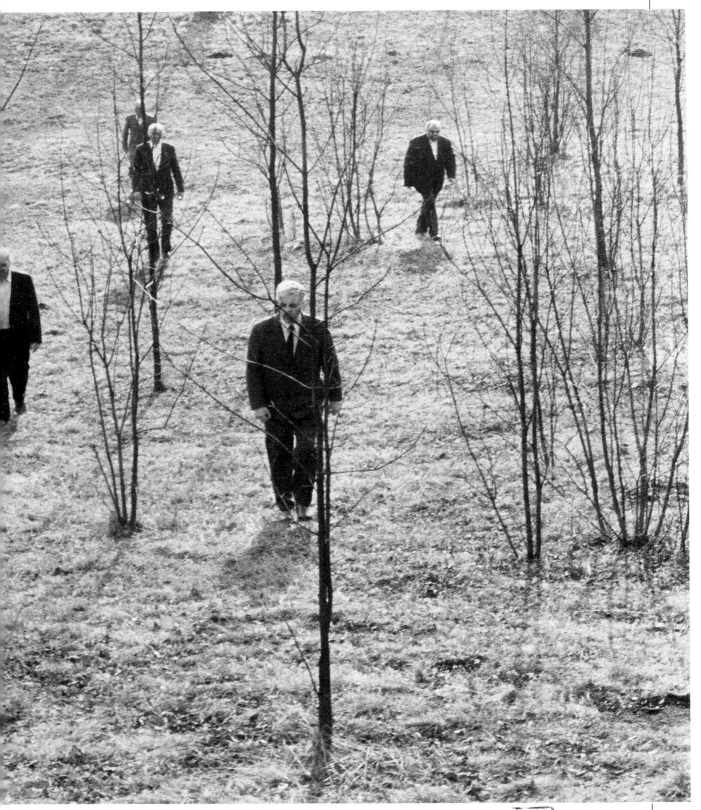

31

frightening estrangement from their cognisable self; now fantasy and the author were one, he or she lived in it and described their actual sensations from the inside. That is, they experienced fantasy as reality, and experience, as we know, cannot be false. (We have somehow drifted to a discussion of art proper — the names are already there on the tip of the tongue. But we shall talk about art in due course — for, as has been said above, art was in this case the final result.)

Thus, fantasy literally acquired live flesh and … was no longer harmless. And this all the more so because to manipulate the other's psyche was no less interesting than one's own. It is amazing how willingly the other's psyche yielded and took the game seriously, whatever its rules were. Viewed from the outside, it seemed inexplicable how it happened: for instance, it was so easy to persuade a person that for the sake of some supreme goal they must transform themselves into inanimate matter, and they diligently tried to identify their self with it; a man was told that he had been placed into a glass

15. Yevgeny Yufit, A shot from the film *Dad, Santa Claus is Dead*, 1991

cube, and consequently lost the ability to act and create; if half of someone's head was stolen in the astral world, a whole delegation arrived to claim it back, all doing so in complete earnest. Such actions were given the benefit of the doubt in that circle. A participant in the events of that time had every reason to assert that their life resembled 'a competition in madness'. Yet, madness was in fact a form of freedom in which any subjective truth could be adopted without correction, without adjusting it to an objective actuality. The latter had fully discredited itself in the eyes of the 'schizoids', if only because it disregarded one's personal attitude to the world, ignored one's individual distinctions and bent one to comply blindly with commonly accepted viewpoints.

It is interesting that while Kierkegaard was re-read in the West (this philosopher was extremely popular in the 1960s), in Russia it seemed as if the Underground culture were trying to prove his ideas in practice. It remains unclear, however, whether the

16. Vladimir Kovenadsky, *Dominoes*, 1975, Colour gravure on paper, 35 x 24 cm, Collection: Kovenadsky family, Moscow, Photograph: Valentin Chertok

Underground was familiar with the original or not. Whatever the case, this culture seemed to subscribe to nearly all of his statements, and in particular, that truth is subjective and that a personality possesses it even when adhering to untruth. The members of the Underground gatherings, the creators of the schizoid tradition seemed to echo Kierkegaard: what is the criterion for the difference between truth and delusion if both are grounded within?

In fact, the creators of the schizoid tradition did not invent anything fundamentally new. According to Michel Foucault, the early nineteenth century romanticists believed that the truth of folie is the innermost sanctuary of human individuality. The Moscow 'schizoids' were more radical and consistent: they became the bearers of the truth. It should be noted, though, that they lived in a totalitarian state where the established standard was perhaps even more terrifying than insanity, and the dominance of generally imposed truths threatened one with a loss of identity. To rescue itself, the rebelled mind of the

17. Vladimir Kovenadsky,

*Dominoes* (Detail)

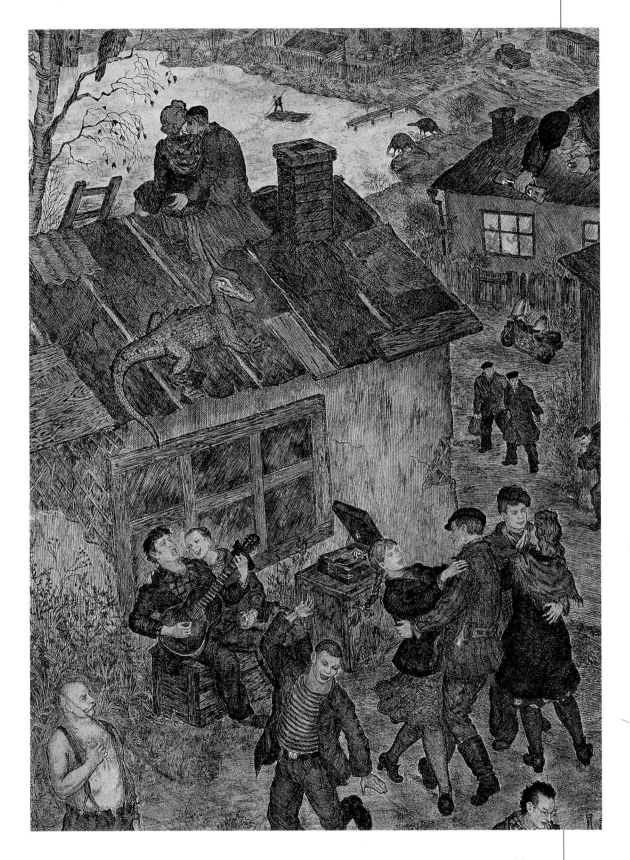

apostates posed, not without a malicious joy, a provocative question: do things actually correspond to our conception of them? Is the world such as we see it from the outside? It is easy to imagine the exciting perspectives opened before the inquisitive mind at the mere assumption that a negative answer might be given to these questions.

These were strange times, when the search for irrational ways of cognition — which were certainly forbidden in this country — started from a point of complete ignorance of them. It is hardly possible to establish today what was the effect and what was the cause of this interest in esoterics. Perhaps it was provoked or at least invigorated by the sudden opening, for a short while, of non-public library depositories, during which time resourceful readers managed to get access to old magazines and books, including occultist literature. They ordered them at random so that the next time, they would be able to get the books the author mentioned in the references. In this way, by hit or miss, they gradually acquired new knowledge.

18. Vladimir Kovenadsky,
*Dominoes* (Detail)

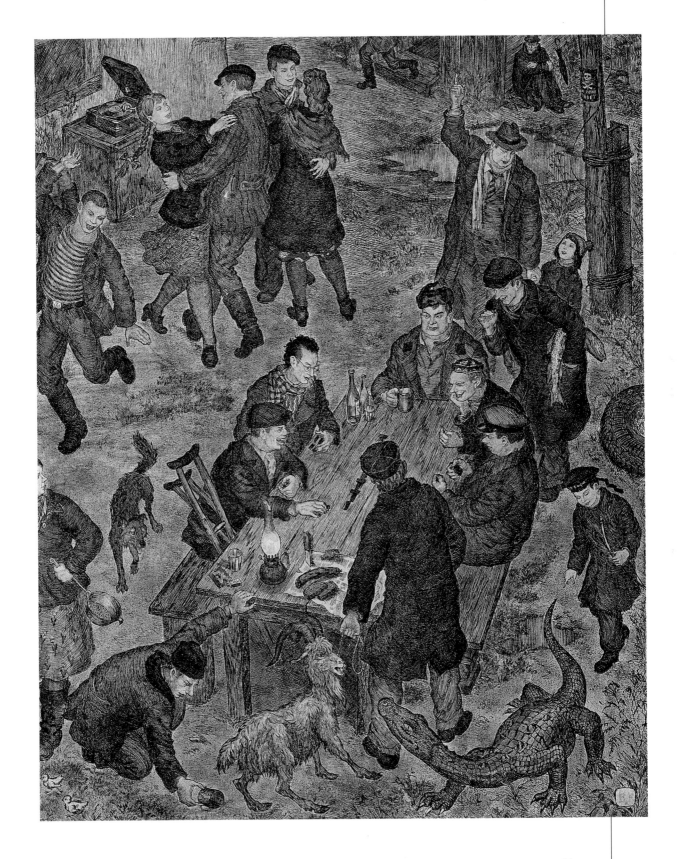

There were home libraries, of course, mostly belonging to the people who had moved to the vacated flats of former owners who had vanished in Soviet prison camps or were in exile. Thus, the Theosophical Society library was discovered in someone's home. The mansion occupied by the theosophists at the beginning of this century was later made into the residence of Lavrenty Beria, Stalin's famous comrade-in-arms, while the library had been taken away by persons unknown. The heirs of the Master of the Russian Freemason lodge possessed a collection of masonic books. But such libraries were rare and few people knew about them. Usually, odd books were found, from which one might derive bits of information on Yoga, Sufism, the Rosenkreuzer society, Georgy Gurdjiev's theory[1], and so on. This was an unsystematic form of reading, of course. As Ilya Kabakov said, it was the epistemological thirst quenched however one was able to, and wherever this was possible. This was not and could not be systematic reading. The range of the

19. Vladimir Pyatnitsky, *A Woman with an Earring*, early 1960s, Paper, ink, pen, 31 x 21.5 cm, Collection: Nikolai Kotrelev, Moscow, Photograph: Valentin Chertok

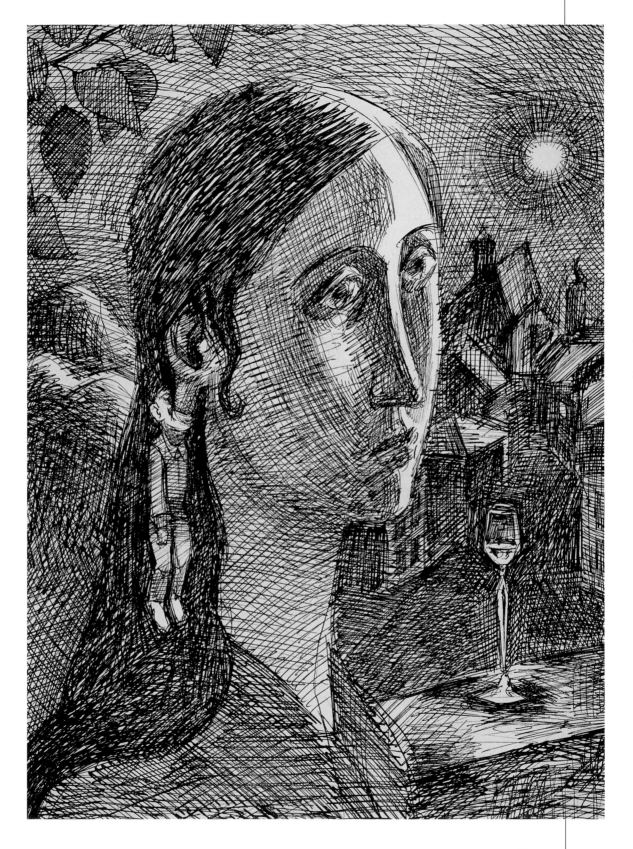

search was as wide as it was sporadic; any chance was taken up, any occasional opportunity, whether it was Madame Blavatsky's book[2] as it passed through numerous hands, a manuscript translation of St Alertus Magnu, an offer to try dual meditation, or a promise to be introduced to a live sorcerer. As the main character in Mamleyev's novel, *Moscow Gambit*, said on being visited by a black magician, 'let it be the demons, the moan of prayer merging with the black world, all the same, being is a gift and it must be divined; even that darkness is better than ordinary consciousness that is barren'.

The absence of a system, the sporadic sources and, what is most important, the lack of real teachers resulted in that epistemological thirst turning into epistemological anarchy. Transported with joy, skipping upstairs two at a time, the homebred Moscow esoterics rushed to resolve eternal problems. None of them had traversed that long and humble path of the zealot which precedes initiation and requires discipline and, certainly, mystery.

20. Vladimir Pyatnitsky, *Yard*, 1975, Oil on canvas, 122 x 97 cm, Collection: Nikolai Kotrelev, Moscow

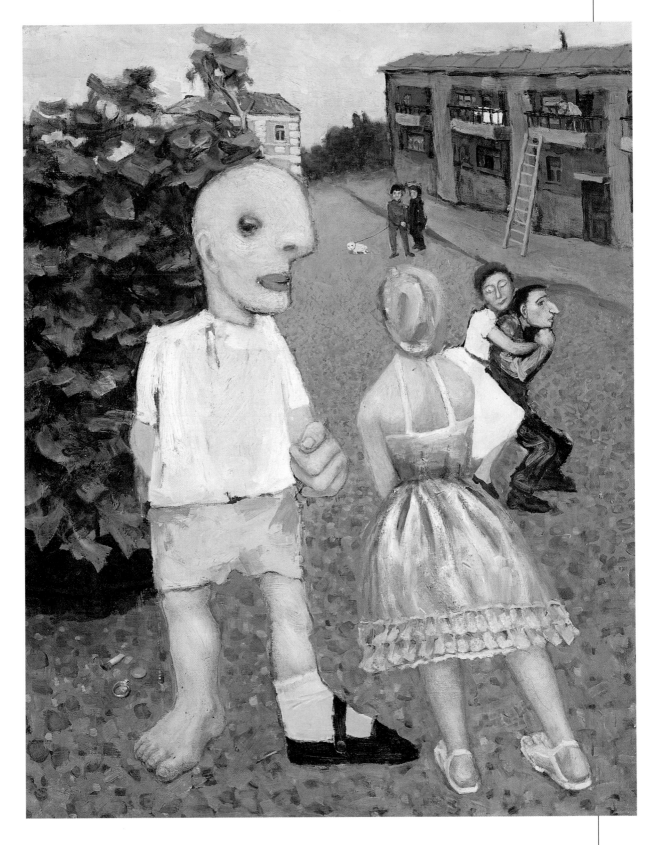

But who could initiate them, after all? Occultism was practised arbitrarily — not by many but, as a rule (or rather, contrary to the rules), without making a secret of it. More often than not, the experiments were staged before the public's eyes; all who wanted to be were well informed, they 'knew' even more than that which was actually taking place, for the tale surpassed the occasion. Intentional mystification could not be excluded either. In a word, such practice, real or mythical, was a life event, it was part of everyday existence, a natural and fixed attribute. The beyond was nearby, one had merely to take one step … Was it possible to withstand the temptation?

It is no wonder that even those who lacked specialist knowledge tried to take one way or another to get there. There were in fact three ways. The first, of course, was the use of psychedelic substances. Some people used them from time to time, but not regularly. Like everything else in this country, they were hard to get. They would smoke grass or take some medicines and ether, but there was only one man in Moscow who secretly

21. Vladimir Pyatnitsky, *Trio*, 1960s,

Paper, pencil, 28.5 x 20 cm,

Collection: Nikolai Kotrelev, Moscow,

Photograph: Valentin Chertok

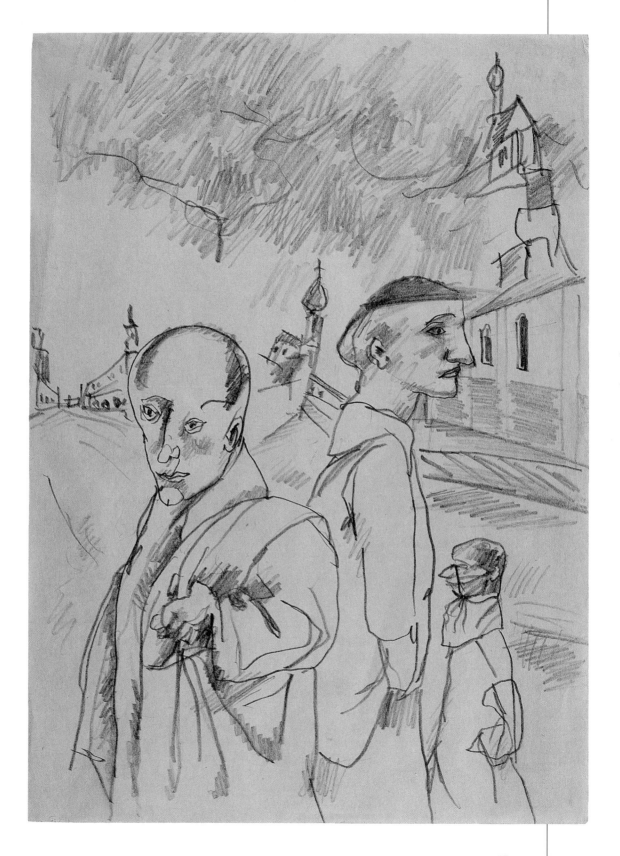

manufactured a narcotic drug, at a research institute laboratory. Whatever the case, practically none of the bohemians of that time were known as drug addicts. There were deaths from overdosing, but those were suicide cases.

The second way was much more innocent. Some believed that the true understanding of things comes in dreams, and reality should be interpreted as its weak reflection. Naturally, this way had a direct outlet in creative work, which partly consisted of an expanded description of dreams.

The most interesting way was the third. It was akin to the second one in that here too the door to the mind was closed, but this was done not while in an unconscious state, in an hallucination or a dream, but as a volitional act in the light of the day. The likely train of thought was that the human mind is unable to break into supersensitive spheres; it

22. Vladimir Pyatnitsky, *The Portrait of Yuri Mamleyev*, early 1970s, Paper, crayon, 14.5 x 13 cm, Private collection, Moscow, Photograph: Valentin Chertok

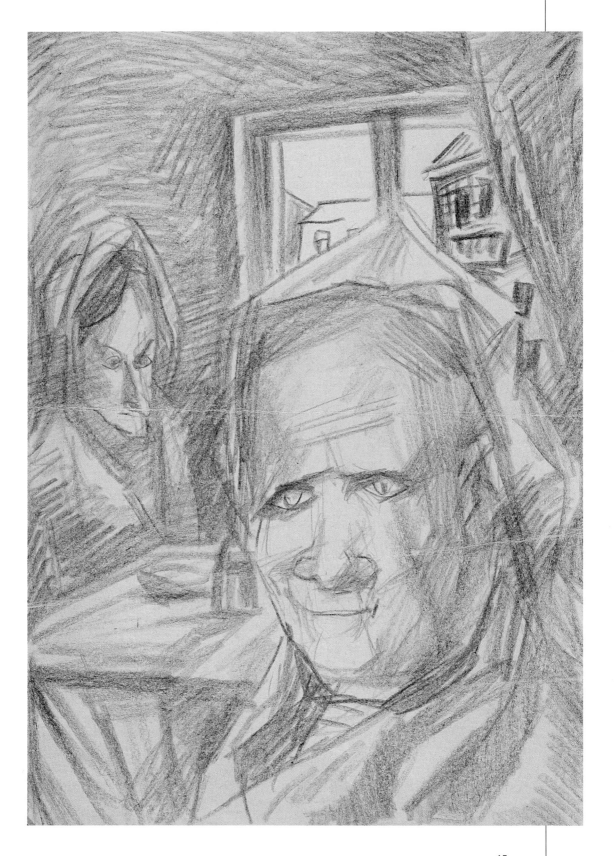

spreads its wings in vain, as Kant wrote, it does not have the power to overcome the gravity of empirical reality. Consequently, the mind is an obstacle which should be removed outright.

Clever people could reject the mind in one way only — by imitating insanity. Now a new aspect, and one of the main reasons for the absolutist attitude to insanity on the part of schizoid culture, is revealed to us: it treated insanity as the vision of mystery.

But the difference between a madperson and all others consists precisely in that he or she lives as if in two worlds at one time. It is not that they simply see something else, they see it through the tangible compactness of things; they glimpse that 'something else' through the gaps of ordinary reality, but they do not notice the presence of the actual gaps

23. Vladimir Pyatnitsky, *Russian Ecstasy*, 1972, Paper, ink, pen, 27.5 x 19 cm, Private collection, Moscow, Photograph: Valentin Chertok

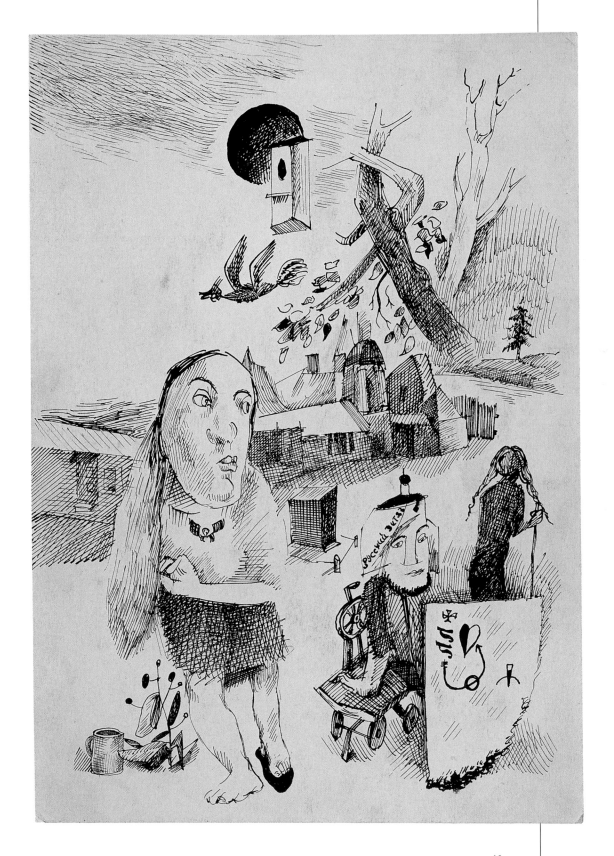

themselves and cannot distinguish between the real and phantom worlds. In the opinion of psychiatrists, a madperson is not one who sees things that are nonexistent in real life, but one who believes they actually exist.

Here we venture to probe the shaky soil of the subtle differences between belief and conviction in respect to the same truth. No doubt, the differences do exist, but how to detect them and how to measure them? In all probability, this is an unanswerable question. The 'schizoids' *knew* about the existence of the unreal but, unfortunately, they were not visionaries (provided they did not really go mad). Despite this, though, their minds were preoccupied with the contemplation of all possible manifestations of the unreal, and when they described their imagined contacts with the invisible things, they did so in earnest! Their minds actually experienced these contacts.

24. Alexai Paustovsky, *Fedya*, 1972, Oil on canvas, 100 x 80 cm, Collection: Plavinksys, Moscow, Photograph: Valentin Chertok

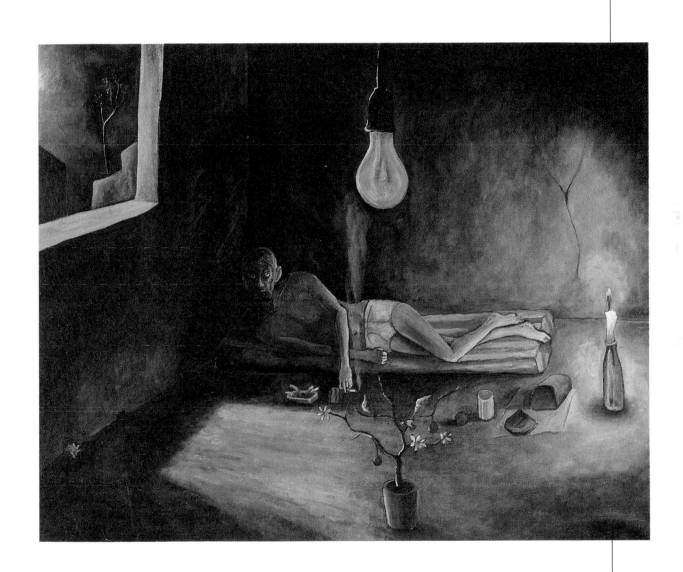

At last we can turn to their art, which perfectly illustrates what has just been said. It is sufficient to look at Vladimir Kovenadsky's gravures or read his verses, like this one, for example:

… To an old fox-trot quacking,

to the rasping groan of an ancient record,

a thin centaur painfully resembling someone

was slowly unshoeing me.

Kovenadsky places his phantasms into the very midst of banal reality. His works look like sketches of life scenes. They are so convincing and naive that one can hardly accuse the author of concoction, and that is why they are so strange.

25. Yevgeny Chubarov, *Sitting Body*, 1976, Paper, wood marker, 35 x 50 cm, Collection: Lev Melikhov, Moscow, Photograph: Lev Melikhov

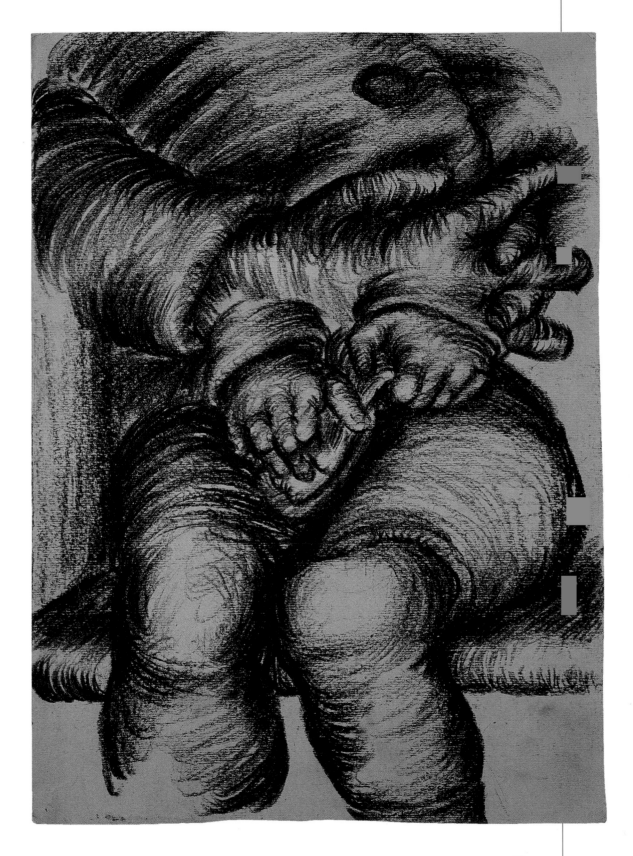

In its early period this culture did not strive to explain immediately the higher order of things. At least, it was not keen on metaphysics; on the contrary, it aspired to depict the mysterious circulation between visible and invisible life that destroyed the usual and properly ordered picture of the world, for, as a character in one of Luigi Pirandello's plays says, 'our assuredness of the reality of the world is hanging by a thin thread of our ordered experience; otherwise we would not discriminate between actuality and the muddle of visions, illusions and dreams'.

When Volodoya Pyatnitsky was in a madhouse (this does not mean he was mentally ill — we all know who was placed there and how!), he produced drawings containing the names of the days of the week which reflect the reality of a dream and a nightmare. It is unclear, however, whether it is a view from the inside or the outside, whether he depicts the surrounding crazy world or uses insanity as a method of depicting the reality he sees.

26. Yevgeny Chubarov, *The Head*, 1974, Paper, wood marker, 32 x 40 cm, Collection: Lev Melikhov, Moscow, Photograph: Lev Melikhov

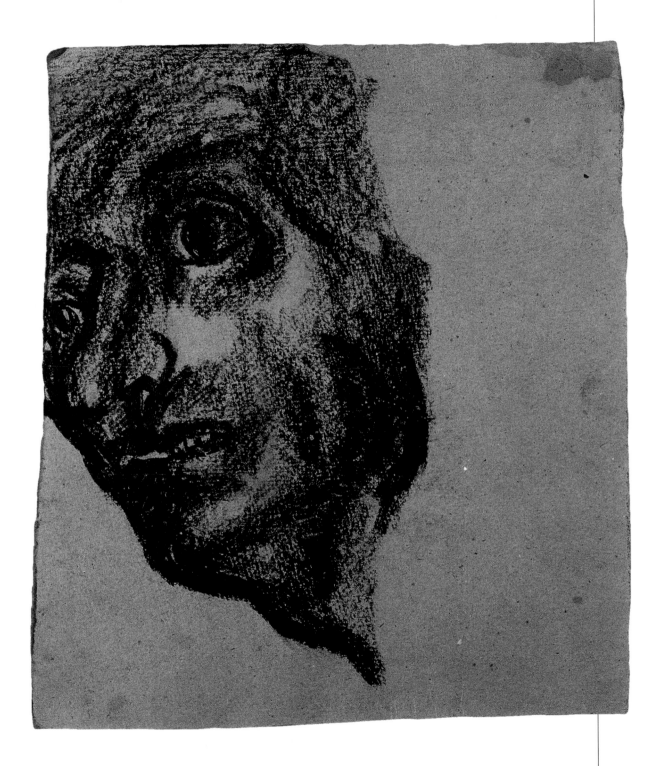

It would be inappropriate to talk here about imitations or masks — the creators of that culture did not clothe themselves in the robes of madness, they inoculated their blood with it; madness became a form of existence for them, and this did not come to pass without its effect. Madness affected them more strongly than drugs. Alexei Paustovsky's picture *Fedya* recreates the typical atmosphere of the Moscow 'schizoids' life, any one of them might take Fedya's place.

Their pathological art was regarded as an unheard-of impudence in those times; indeed, they assailed not the form of representation sanctioned by the Communists, as did their fellow Underground artists, but the holy of holies — reality itself! Pyatnitsky believed, for instance, that his models were the people in the street, that what happened in life was just what one saw in his pictures. And Kovenadsky, too, painted the barracks and the yard where he spent his childhood, he depicted his family: his father, sister, himself as a young

27. Vladimir Yakovlev, *Portrait*, 1975, Paper, gouache, 86 x 61 cm, Private collection, Moscow, Photograph: Valentin Chertok

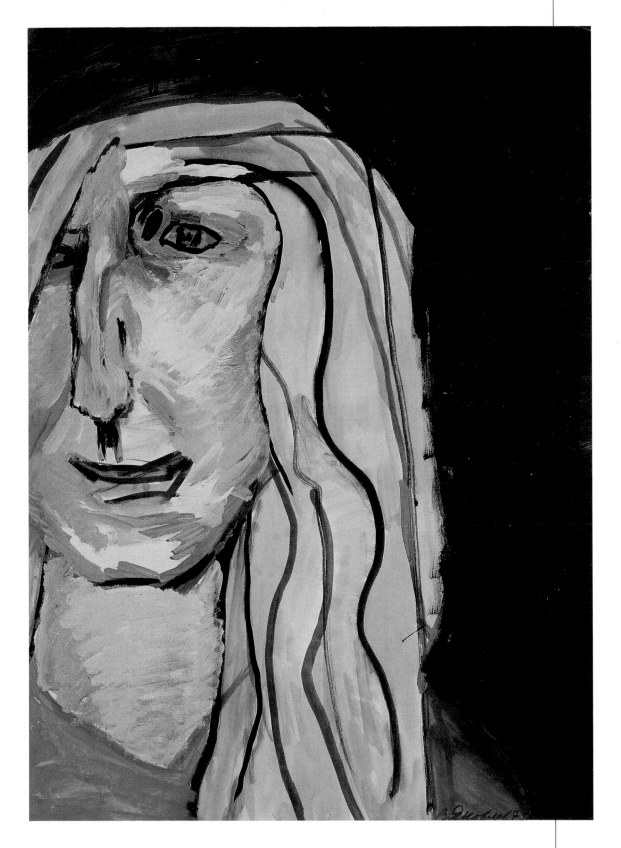

boy, his former neighbours, a watch-dog and, among them, a live dinosaur running on the roof, and two small ones watering at a distance. From their very inception, such works by the 'schizoids' were not orientated toward the solution of some artistic tasks in anticipation of the viewers' assessment, that is, as 'products of art'; rather, they were an instrument for self-articulating the contents of their own minds and souls, which pressed from the inside and cried to be given vent.

A student of this art is faced with the danger of falling into two kinds of fallacy. An art critic may easily take the works of these artists as the echoes of Impressionism or even Surrealism, and this would be a grave error, for their judgement will be superfluous, with no consideration given to the meaning of this phenomenon and its cultural significance. If a psychologist takes up this subject, they may run to the opposite extreme, writing, for instance, that 'the form of depiction is but an instrument to fix pathological impressions;

28. Vladimir Yakovlev, *White Flower*, 1984, Paper, gouache, 59 x 84 cm, Private collection, Moscow, Photograph: Valentin Chertok

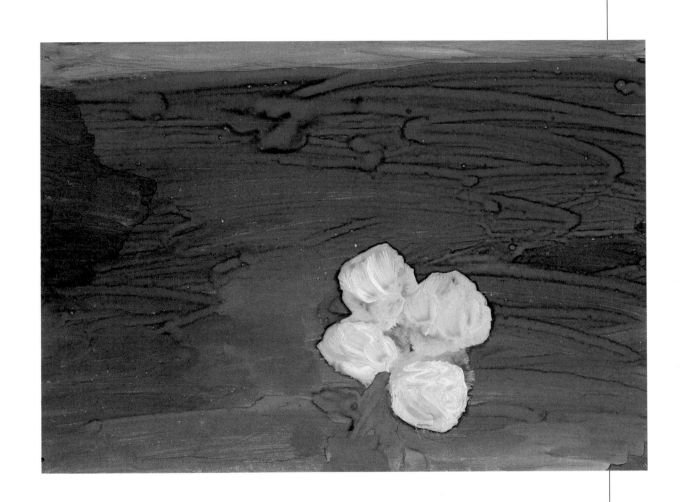

the choice of expressive devices is sporadic and subordinated to the task of self-description'[3]. This is how Vladimir Yakovlev's work was characterised in a psychiatric research into mental patients' creativity. One might agree with the first part of this statement if it were not for the categorical and restricting conjunction 'but'. Michel Foucault devoted a whole chapter to the problem of folie and creativity in his famous book[4], pointing out that it is a complicated task to determine what is the product of folie and what is the product of art, what is the fruit of inspiration and what is phantasmic, what is spontaneous mumbling and what is the creation of a new idiom. There is no need to add that not every madperson who is keen on painting is a true artist. Delusion may nourish creativity but, again, Michel Foucault is right in saying that folie ends where a work of art originates. We see works of art when looking at Yakovlev's paintings.

29. Vladimir Yakovlev, *Portrait*, 1976, Paper, gouache, 89.5 x 64.5 cm, Collection: Stolichny Bank, Moscow, Photograph: Valentin Chertok

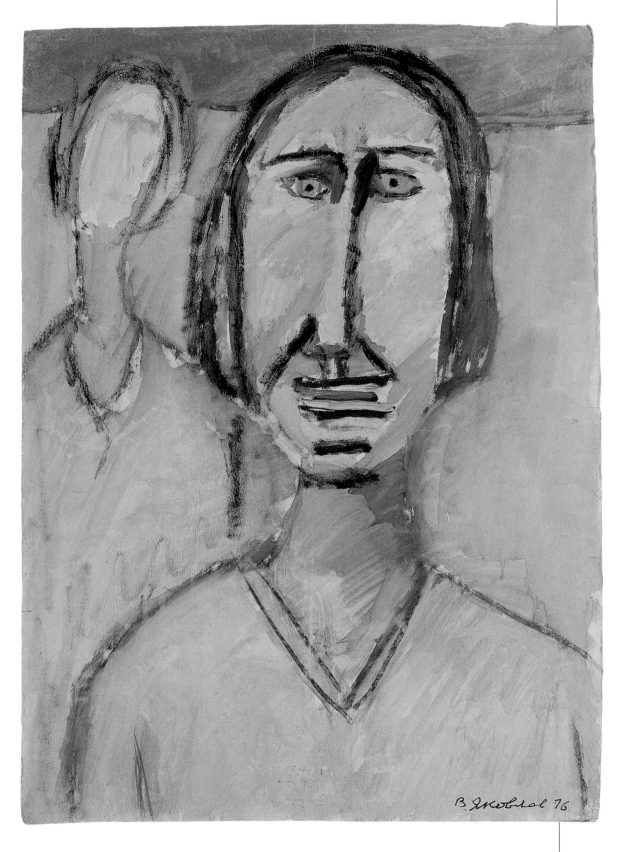

B. Якованд 76

As we have touched upon this subject, it would be interesting to discern the invisible line where his visionary experience and artistic sense merge. What makes him frame the picture in such a way that the face is cut by the edge of the sheet, as if the artist did not manage to keep the whole and snatched only a fragment of a vision when it stood before his eyes, for then it disappeared like a dream that could not be remembered and represented? Where do his flowers grow, so fresh and so detached from our surroundings, solitary and unique? They seem to absorb the spiritual energy the artist has transfused into them and exist due to this sacrifice; they blossom on the other side of the sheet's surface, on the other side of everything that constitutes our reality. It is not our imagination, but the painter's brush that creates this enchanting illusion of a live substance taking the form of a flower. That is why the madness showing through this artist's paintings is simultaneously perceived as the gift of a specific artistic vision and also as self-exposure, which was no less valued.

30. Vladimir Yakovlev, *The Cat*, 1980s, Paper, gouache, 82 x 115 cm, Private collection, Moscow, Photograph: Valentin Chertok

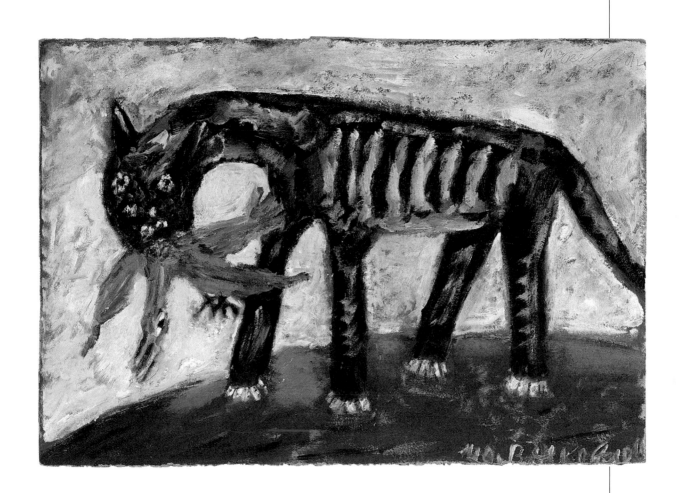

Back in the past century culture had already found madness attractive, precisely because it 'exposed the depths of the human soul'; a hundred years later the awareness was gained that these depths are bottomless. Plunging oneself into the chasmal dark waters, one gets into the domain of one's individual psychic experiences, suppressed instincts and lurking phobias; one may also penetrate into the more remote strata where, as Jung wrote, one suddenly discovers infinite vistas, unbelievably indefinable, where there do not exist either the internal or the external, top or bottom, here or there, mine or yours, there is no good and evil. There are no obstacles to prevent one from coming into contact with the sacral, which is perhaps more dangerous than the subconscious desires controlled by the mind. A rational person would rather avoid those strata, but in all ages irrational people have seemed to believe, like Hölderlin, that where there is danger, the chances of salvation grow too. Although it is difficult to say definitely whether all Moscow 'schizoids'

31. Collective Actions group,
*Performance 'M'* (Metro), 1983

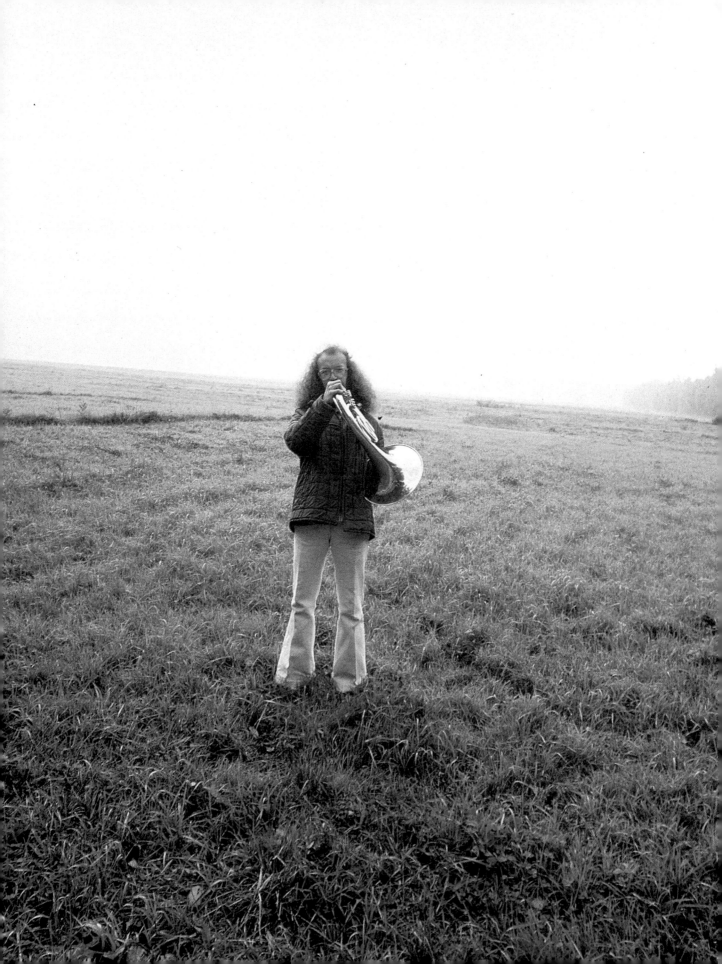

managed to descend (or ascend?) to those depths, they were all psychologically ready to meet with the sacral and felt their natural, even intimate, relationship with the supernatural, which Jung called *participation mystique*. Gadding about studios and basements, slimy doorways and filthy yards, the slushy Moscow streets and cheap beer bars, these free-will madpeople felt the firmament of the Universe under their feet, where they shared their fate with all inhabitants of the higher and lower worlds.

There is a passage in the novel *Kashirskoye Highway* where Monastyrsky describes how he got lost in the suburbs and tried to return home at night: 'I made for the platform, it was empty. The clock showed 2 a.m., there were no more trains. I did not know what to do. There was a yellow police phone on the ticket office wall. I lifted the receiver and heard short signals, as when the line is busy. I was calling God, I wanted to ask Him what to do and where to go, but the telephone was engaged and I hung up the receiver.'

32. Collective Actions group,
*Performance 'M'* (Metro), 1983

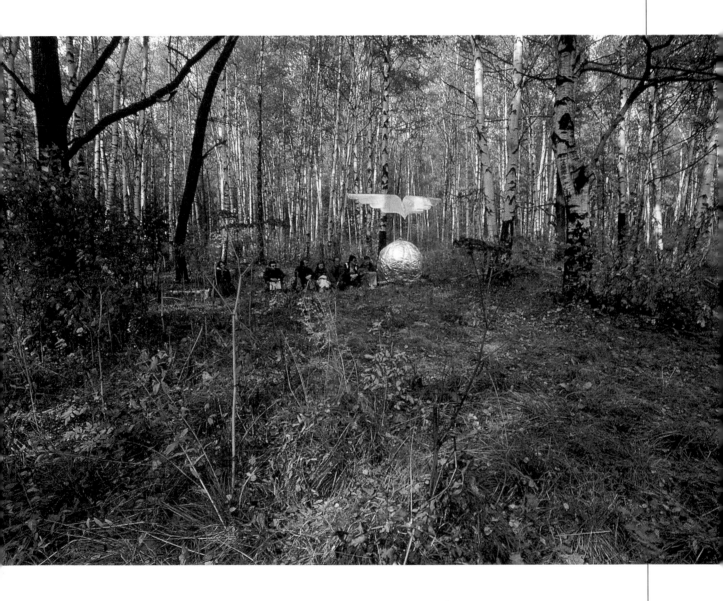

It must be expected that a person confident of the existence of incorporeal forces nearby will sooner or later see them 'with the same degree of probability', as Monastyrsky says, 'that we can meet a hare in a wood'. It is not so important, after all, whether the likely meeting was taken as a possibility or as an accomplished fact. It is more significant that such an experience came into irreconcilable disagreement with the mind, which tends to adjust itself to the external flow of life, which would not and cannot encompass such things. But the less the harmony between experience and the mind was, the stronger became the need to pour it out onto the surface, otherwise there was a danger that the person would not withstand the pressure of that chasm, which greatly surpassed the

33. Left: Dmitry Prigov, *Portrait of Leon Trotsky*, 1985, from the 'Bestiary' series, Paper, biro, gouache, 28.5 x 20 cm, Private collection, Moscow; Right: Dmitry Prigov, *Portrait of Mikhail Kutuzov (with Napoleon on His Shoulder)*, 1985, from the 'Bestiary' series, Paper, biro, gouache, 28.5 x 20 cm, Private collection, Moscow

narrow limits of their consciousness. Art was the only safe outlet for out-of-the-ordinary psychic experience; in this case, art was therapeutic, it served as a mediator between external reality and the troubled depths of the subconscious and eased the dangerous conflict of the soul and the world. (Here we might refer to Lev Vygotsky, the outstanding Russian psychologist, who wrote about art being 'the social resolution of the subconsciousness'.)

At this point it would be appropriate to reread the citation from Monastyrsky given at the beginning of the text. As we see, he is not in a hurry to discard his experiences; on the contrary, he wishes to preserve them, albeit stepping back to keep a safe distance from them. And he resolved his problem as soon as he transferred the substance of his

34. Top: Dmitry Prigov, *Portrait of Riza Pahlavi*, 1985, from the 'Bestiary' series, Paper, biro, gouache, 28.5 x 20 cm, Private collection, Moscow; Bottom: Dmitry Prigov, *Portrait of Leonid Brezhnev*, 1985, from the 'Bestiary' series, Paper, biro, gouache, 28.5 x 20 cm, Private collection, Moscow

hallucinations and morbid illuminations to the sphere of artistic conventionality. He himself took the position of the author, that is, the master of his phantasms, which had earlier imposed themselves despotically and infiltrated his consciousness whether he wanted this or not. Now he materialised these phantasms in a sphere in which there was nothing but the pure play of self-dominating signs, and these bore no threat, as they were isolated from the coherent stream of life.

The performances arranged by Monastyrsky on the basis of his marginal psychic state were described in the third volume of *Trips to the Country* in 1983–85. We shall render one of them in brief, but first the prehistory.

35. Vladimir Sorokin, Untitled, 1990, Installation, Contemporary art collection, Tsaritsyno Museum, Photograph: Valentin Chertok

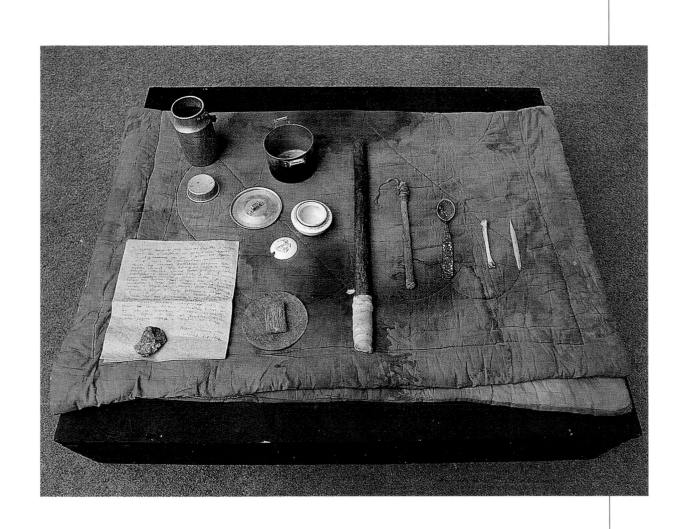

On one occasion in that winter of 1982, when all events took another mysterious meaning in Monastyrsky's consciousness, he was training somewhere and noticed the small emblems on the guards' uniforms — tiny silver wings. He guessed that he was seeing angelic creatures before him, the sign testified to it.

A year later, when he was once more in his right mind, he staged a performance together with other members of Collective Actions in a big field near the Kievy Gorki village. The participants (called 'viewers' by the CA) stepped out of the outlined circle one by one to the accompaniment of the sound of a moving escalator and crossed the field. At the opposite end of the field they were met by a 'herald' playing the trumpet. When they approached him, he told them where to go. They went on and found a glade where huge silver wings with a golden sphere below — the giant 'copy' of the Ministry of Railways emblem — hovered low over the ground.

36. The Medical Hermeneutics Inspection, *Polishing Little Larvas*, 1989, Photograph, text, Project for *Flash Art* No 1, 1989

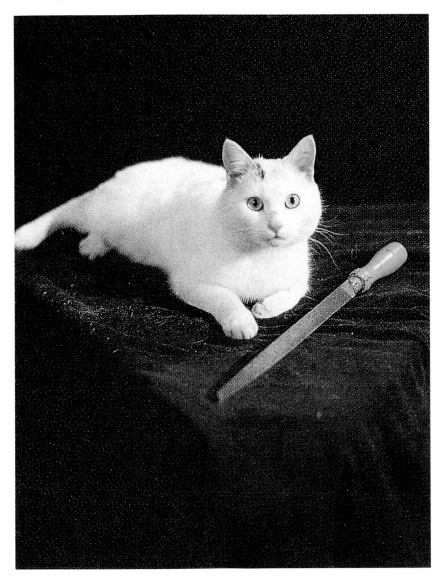

Sometimes it takes so much time to create and polish little larvas in opposition to discourse that the cost of the item (as the measure of the effort spent) grows enormously. For this reason, it would be pretty expensive to throw away a larva after it has been used; besides, as its making is a long process, the larva will all the same make a tardy appearance to fit in the situation.

That is why the larva-articulation persists nearly eternally in its opposition not to something concrete that has long vanished, but to the indivisible 'all'; it lasts till its multicoloured ideological attire wears out completely.)

The performance took place without commentaries. Each participant experienced what they saw with their own eyes, hardly understanding that they had been passing from the underworld to the paradisiacal spheres. Strange as it might seem, the moment that the 'sacral symbol' was materialised in the performance, it turned into a figure of preterition; its 'body' separated from its meaning and began to live its own life, the life of an aesthetic object. It is interesting that the falling of the 'body' from the 'spirit' was quite in concert with the division of the participants into the ignoramuses (viewers) and the initiates (the action organisers). In this way, the distribution of the roles was reminiscent of cult rituals. However, this thought was too abstract to interfere with the event: the good weather, hiking about the country in the company of nice people, the rustling autumnal woods — these mattered most.

37. Igor Makarevich, *Monument*, 1974, Oil on canvas, 130 x 105 cm

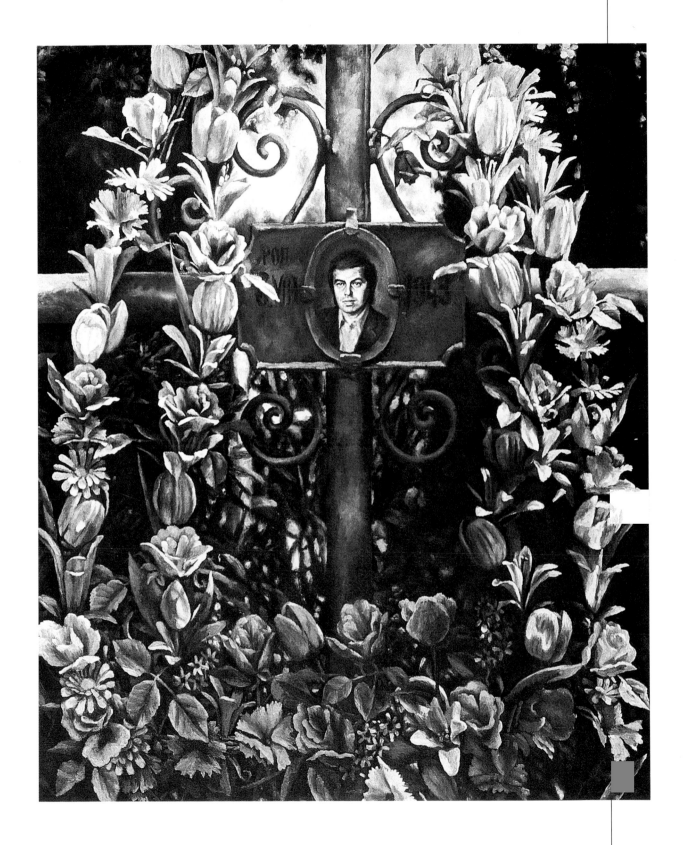

From a formal point of view, Monastyrsky's gesture contrasted with the ventures of his predecessors: he did not reveal the hidden meaning of things; true, his purpose was to make it an object of endless mental search. And this was typical of Conceptualism.

Now we have approached a rather interesting problem, that of constancy and change, succession and difference, which, taken together, form the schizoid tradition. This means we are to consider the concrete results, at its different stages, of an infusion of certain doses of madness into culture (here we may only regret that our material is restricted to the contemporary Russian school).

The rise of the schizoid tradition is usually connected with Yuri Mamleyev's work. Many felt his influence and without him there would perhaps be none of the lightness with which the younger generation later took up the forbidden subjects. Here we have a good

38. Igor Makarevich,
*Transformations*, 1979, Photoprocess,
Author's property, Moscow

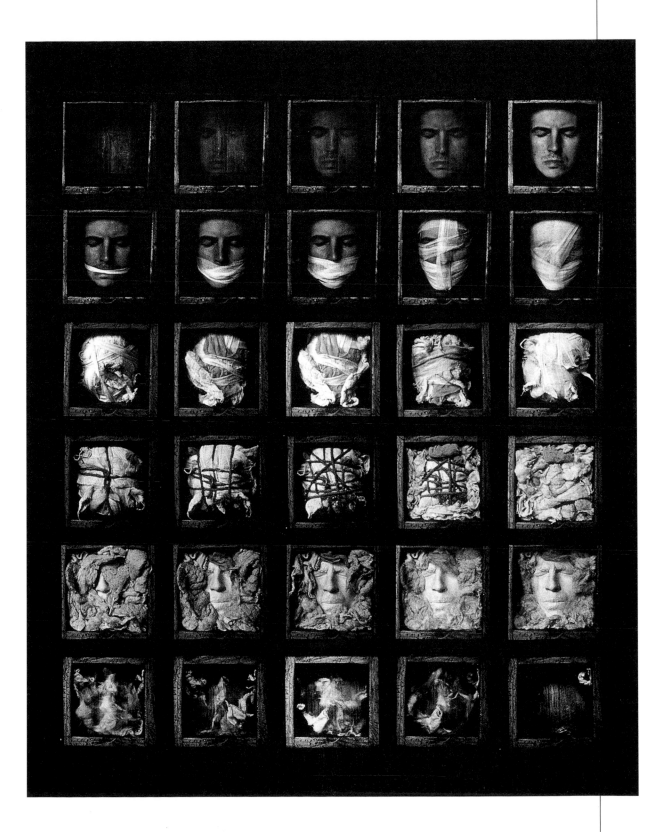

ground for comparison, because neither Mamleyev himself nor others active in the 1960s possessed such lightness. It was more of an epistemological anguish with Mamleyev, caused by the violation of taboos; in his works this was manifested in his trespassing *the limits of that which man was allowed to know* about God, the beyond, and, what is most important, about another individual. Reading Mamleyev is the same as wandering over the basements of the human psyche, and this is a far from pleasant journey, for it acquaints one with such intimate and remote areas, leads one to such murky and reeking blind alleys that none of us would probably wish to see. Jung's aphorism comes to mind: that digging up the soul resembles the laying of a sewer. Mamleyev exposed those aspects of human nature which nobody risked mentioning, let alone showing, as he did: its base instincts, its cruelty and its orphanhood.

39. Igor Makarevich, *Reincarnation of St Ignatius' Relics*, 1992, Installation. Detail, Author's property, Moscow

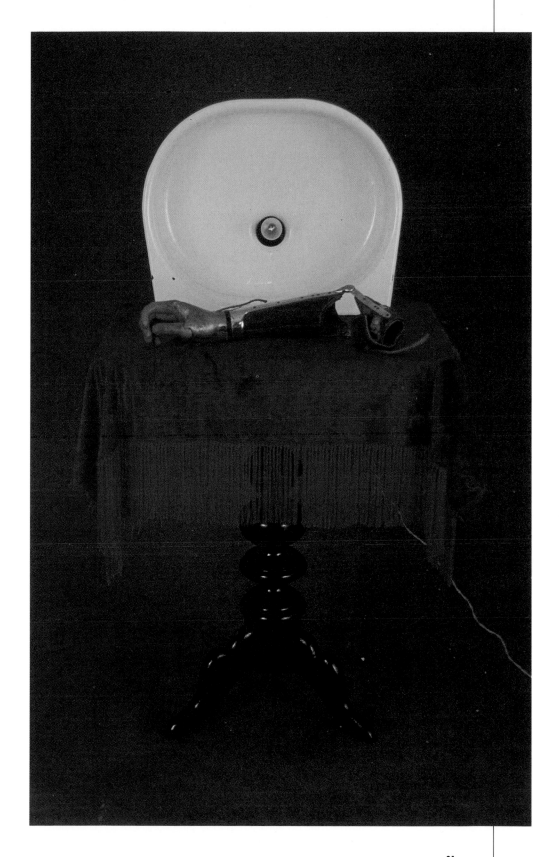

No doubt, Mamleyev's personages are pathological. But, although it sounds unflattering to us, 'he describes the pathology of a normal man' — this phrase was uttered by old Professor Gillershtein, the well-known psychiatrist who once visited Mamleyev's recitation. One thing may reconcile us with this utterance, the assurance that the mind of normal people avoids meeting its Shadow and does not admit even to itself that they are of the same origin. Only insanity divulges secrets which, as was said a century ago, are made secret so that, for their own good, people would not discuss them out loud.

It is interesting, however, that Mamleyev's radicalism does not infringe upon the literary form itself. Here he is entirely in agreement with and follows in the steps of nineteenth century Russian classical literature, he owes it a debt of gratitude. It was typical of the Underground of his generation to cross out the Soviet period from the history of Russian culture; there is nothing strange in the fact that Yuri Mamleyev and Fyodor Sologub[5] might become neighbours. This rapprochement was one of necessity, for how else might

40. Igor Makarevich,
*Reincarnation of St Ignatius'*
*Relics*, Installation. Detail

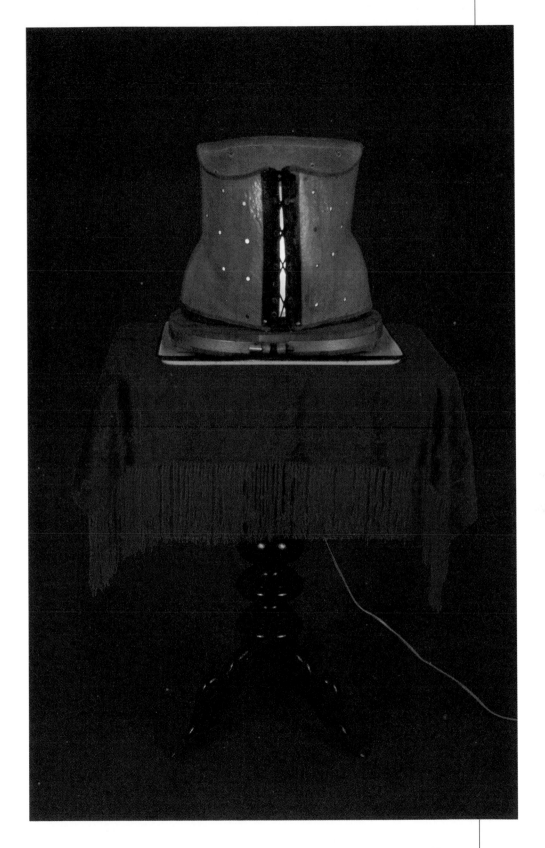

the gaping hole, the giddy gap in time be stopped up. The generation of the sixties had to find firm soil if they rejected the underlying history. This is also the reason why they wanted to take root in the past, why the search for new forms was, for them, also a return to the old paths untrodden by them, even though their task was to go forward, rather than to accomplish over again what had already been done.

Mamleyev, too, uses nearly the same language as Dostoyevsky or Chekhov. The thing is not that his language is somewhat antiquated, it is his attitude to words. Anyone reading classical literature will feel the effect of its language, which appeals not to the ear but to the eye, making one 'see', clearly imagine what is described in the book. The verb 'depict' suits him better than 'pronounce'. To *read* in this case means to plunge into the feelings caused by that which stands *behind* the text, where the words take the appearance of things, merge with events, and are intonated by other voices. Such literature shows to the reader not the text, but the world, and whether it is beautiful or ugly, moral or vile, the

41. Yuri Leiderman, *Sketch*, 1993, Colour photograph

language is not responsible, for here a deception peculiar to literature comes into play: it suggests to the reader that the world came into being before the words that describe it. That is why Mamleyev's language is faultless, the decay of pathology did not touch it — his language fixes the symptoms of the illness, but does not become its carrier.

This was to occur two decades later, with the appearance of Vladimir Sorokin, at which point pathology poured over the brim and began to corrode the language, turning it into a stream of obscenities and demented babble, unthinkable and unpronouncable. Where Mamleyev describes something unacceptable, Sorokin reaches the areas of the unimaginable and impossible. But the gist of the matter is that the impossibility of the situations he describes comes hand-in-hand with the verisimilitude he achieves with such brilliance. However, the secret of this verisimilitude lies not in the fact that 'it may happen in life', but in the fact that 'it may happen in the text' — Sorokin is an

42. Yuri Leiderman, *Sketch*, 1991,
Colour photograph, crayon, ink

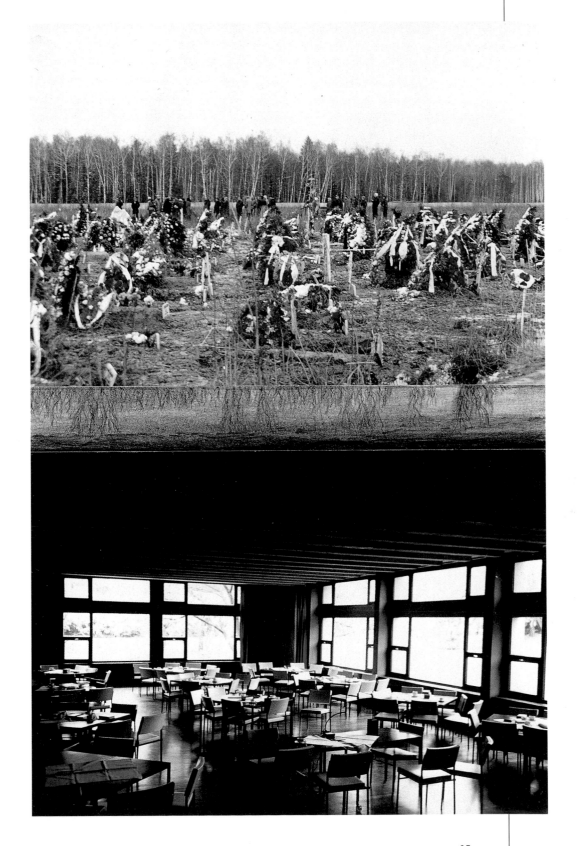

unsurpassed imitator, a genius in verbalism, he is capable of accurate representation in the style of any literary tradition, with the plots, characters and subjects that are typical of it . He achieves the effect of *déja vu*: everything in his text is too familiar, too 'literary', all is as it should be, and this puts the reader off guard. Thus, being absolutely unaware of this, you may communicate with a madperson taking them for a normal person until all of a sudden you are amazed to discover that you are dealing with a crank. The reader may experience something like that reading the following passage, for instance: '... it's impossible to understand how one may not love the trunks of native birches. A man born and raised in Russia doesn't love his nature? Doesn't see its beauty? Its meadows? The forest in the morning? The warble of the nightingale? The steppe vistas? The Russian song? The Russian character? Are you Russian? Were you born in Russia? Did you go to the secondary school? Did you write compositions? Were you in the army? Did you work at a plant? Have you been to Bobruisk? Have you ever been to Bobruisk? Have you been

43. Yevgeny Yufit, *The Feast of Asphyxia*, 1989, Oil on canvas, 150 x 200 cm, Private collection, Moscow

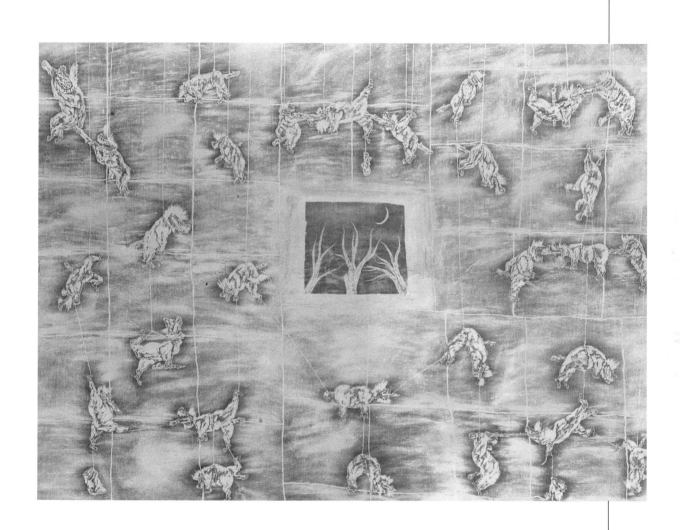

there, eh? Have you? Why don't you open your mouth? Have you been to Bobruisk? Have you, skunk? Have you, scum? Don't you whimper. Have you been there, son of a bitch? Don't you snivel, scum, don't …'[6]

Who is saying this? It is clear these are not the author's words, but there is no character in this story who might pronounce this direct speech. Thus it is the language itself that cries out the words, it simply delivers the phrases that have stuck to it, without any justification except for its own memory. It seems everything corresponds here both to the spirit and letter of Roland Barthes' conception of contemporary literature, according to which the author becomes the anonymous person, a scribe who has to repeat what was already written before them, being led by the language, and the most they can do is to mix and push together different kinds of writing. However, Barthes' crowning assertion in this

44. Sergei Serp, *How Young We Were*, 1990, Oil on canvas, 153 x 196 cm, Private collection, Moscow

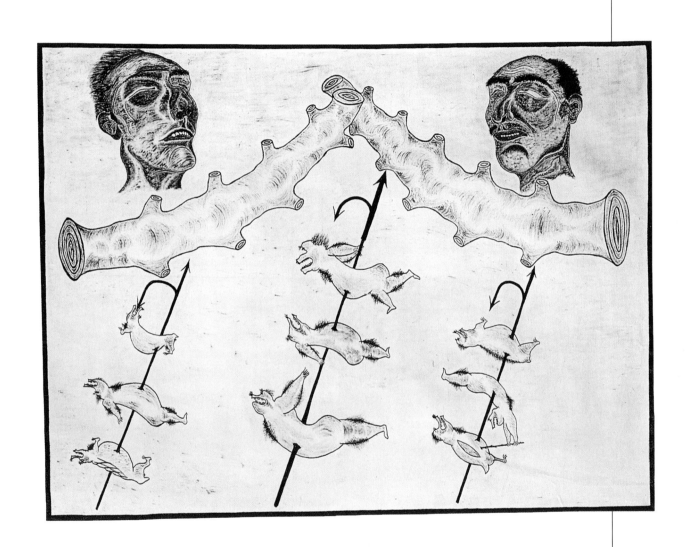

theory, that the author's death gives unrestricted rights to the reader, is absolutely refuted by Sorokin's works. The reader does not have the slightest power over the text, the latter does not yield to interpretation, since the causal relationships appealing to consciousness are broken in it. Rather, the reader is given the role of the text's victim, because they are deceived in their expectations by the text, because the reader is unable to 'crack' it, to catch the on-going idea; because the text runs mad and starts saying terrible things which cannot be explained. Even if misunderstanding is salvatory for the reader, this does not mean that the words stop affecting or impressing them. On the contrary, the impression grows stronger, since the language of madness infiltrates the orderly narration rather than keeping a distance; there are no quotation marks, which would have been tolerable. The reader themselves has to arrange quotation marks in their mind when, recovering from the shock, they remember that they are dealing with literary conventionality, that there are before them, as Sorokin says, 'only letters on paper'.

45. Oleg Kulik, *Piggy Gives Out Gifts*, 1992, Performance, Regina Gallery, Moscow

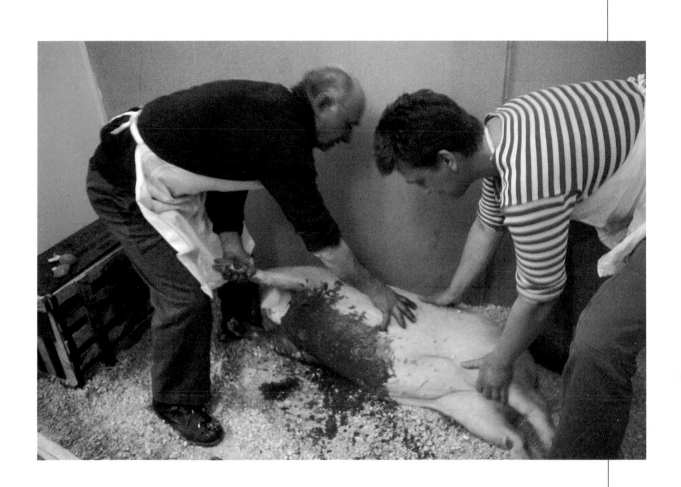

From time to time Sorokin becomes unfaithful to literature and makes an installation or an object. But regardless, the things are accompanied by texts; even in such works the outlines of a literary genre show through: an epistolary confession (*The Parcel*, a sentimental novella (*The Sauce-Boat*), or a magic incantation (Installation on a Blanket). Into the traditional shell of a genre, into an antiquarian vessel that reminds one of the sacred values of culture, Sorokin places something very remote from them, that which has always been outside the limits of art, that is, he sacrilegiously substitutes 'the ignoble' for 'the sacred'. Through the artist's malicious intent, culture is caught in its own trap and can no longer withstand this bursting pathology, but it involuntarily sanctifies all those products of human decay and physiology: faeces, pus, and similarly repulsive things, to which both things and words refer over and over again in Sorokin's works.

46. Alexander Elmar, *Thanatos*, 1993, Installation, Squat in Rozhdestvensky Boulevard, Moscow

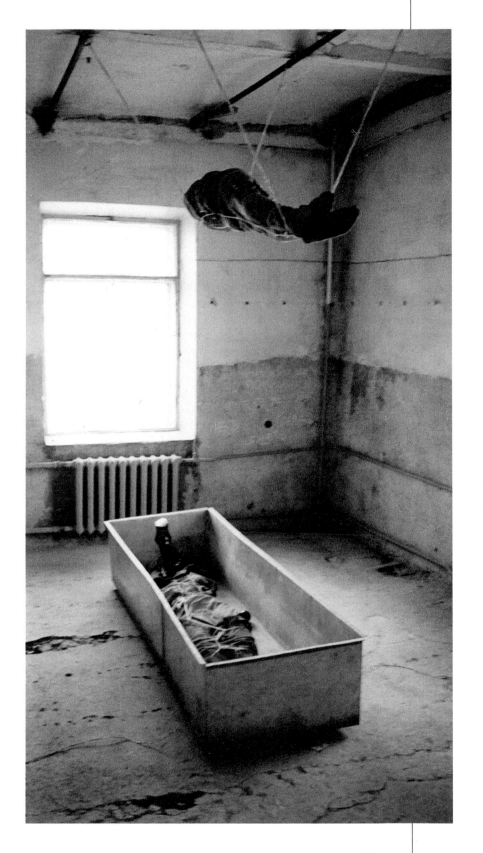

It would hardly be productive to look for the links between Kovenadsky and Pyatnitsky, who belong to Mamleyev's circle, and the representatives of Moscow Conceptualism — Kabakov, Monastyrsky, or Sorokin and others. A language barrier stands between these generations of artists, and even if they tried, they would not hear each other. The only one who found a niche in the consciousness of the Moscow Conceptualists was Mamleyev himself, and in their consciousness he became an idea (his immigration contributed to this) — the idea of *permitted* madness. What an insignificant nuance! But it sufficed, not only to deprive madness of its halo of illegality and mystery, but also to change radically the order of things: culture came into possession of madness, acknowledging it as its own lawful property (it was vice versa in the 1960s). This meant that henceforth an artist could measure off for themselves the required dose of madness, scooping it like paint from a can, and adding it with ease to the other components of their art.

Ilya Kabakov acted in this manner, inventing characters possessed by various maniacal ideas: one collected rubbish, another was obsessed with a dream of flying to space

47. Anatoly Asmolovsky, *Chaos — My House*, 1993, Colour photograph, 150 x 100 cm

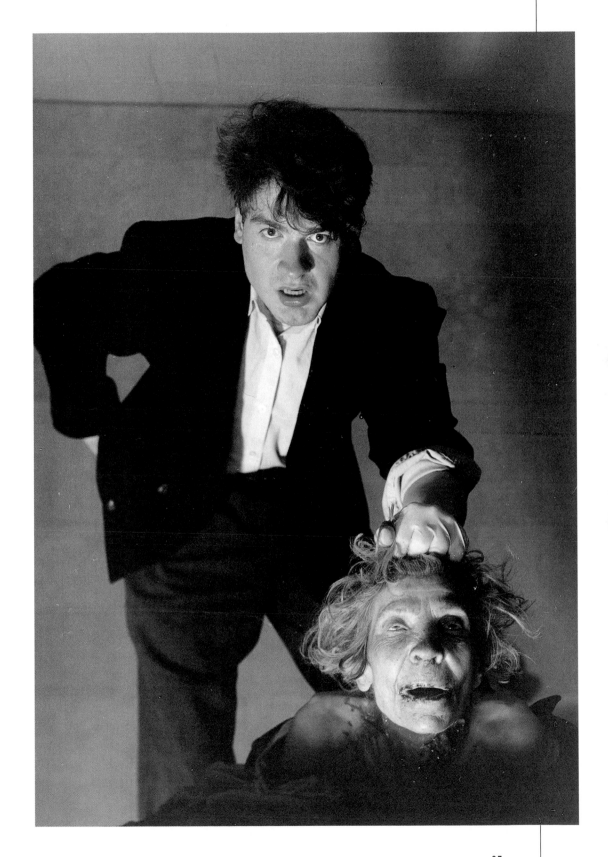

through the ceiling of his room (the installations 'The Dusty Man's Collection' and 'The Room of the Man Who Flew to Space'). Dmitry Prigov does the same, but, unlike Kabakov, he personifies his characters and to prove it, gives them his name. It is clear whose model he uses when he takes the image of the Other and, more than that, insists that the Other is no one else but himself, Dmitry Alexandrovich Prigov. Such extravagant behaviour in art might be taken as mere acting if it were not for his confusing creative output: Prigov-Poet, 'a man of common origin', wrote innumerable verses, and his 'Bestiary' is similarly impressive: a series of paintings executed as if in a hypnotic trance, paintings suggested to him by some medieval mystic who came to him from the remote ages. Of course, Prigov plays, but perhaps not the roles of the characters he invented; rather, of the actor who entered into their images and continues to live in them, forgetting who they actually are. With Prigov, that which we call creative process includes the moment of such fusion with an alien language that there is no longer a need to imitate it, for the author can already *speak* it.

The entire artistic practice of the Medical Hermeneutics Inspection rests on the foundation of that slight mental pathology in which the mind falls out of the space of human communication (irrespective of the cause, whether it is depression, psychedelic preparations or an intentional pose). 'Depression,' writes Pavel Pepperstein, the

ideologist of this group, 'starts as a fairy tale: the mind finds itself in a dark forest and gets lost; it is surrounded by initiating "magic riddles" and further life seems to depend on whether the correct answer is given or not. But the mind does not know the answers, it suffers a "great defeat" in its hermeneutic efforts. The inability to find the answer to a "magic riddle" turns the depressed person into a "stupid corpse", a "stiff-fool", that is he falls out of the plot somewhere down and sideways, he gets into a mental pit, a tight and narrow coffin of "symbolic death" ... Being isolated in its coffin, the swelling mind of the depressed person no longer has any effective communication with the outer world except for the schizoid "rapport by narration". But it is precisely schizophrenia that in this situation embodies the acting instinct of self-preservation. Schizophrenia provides technical services to the depressive "coffin", mounts in this "coffin" the transdiscourse "phones", "TV sets", "walkie-talkies", "telegraphs" and "faxes".[7] That is, the mind, free from collective consciousness, starts to find its own, unexpected links between events and things and to give them its own crazy explanations, but it should be noted that this is an intelligent and actually very clever craziness. No wonder so many artists of the Moscow school were infected with it, and that the traces of the influence of the Medical Hermeneutics method of self-description can be found even in their ideological opponents, such as Anatoly Osmolovsky or Alexander Brener.

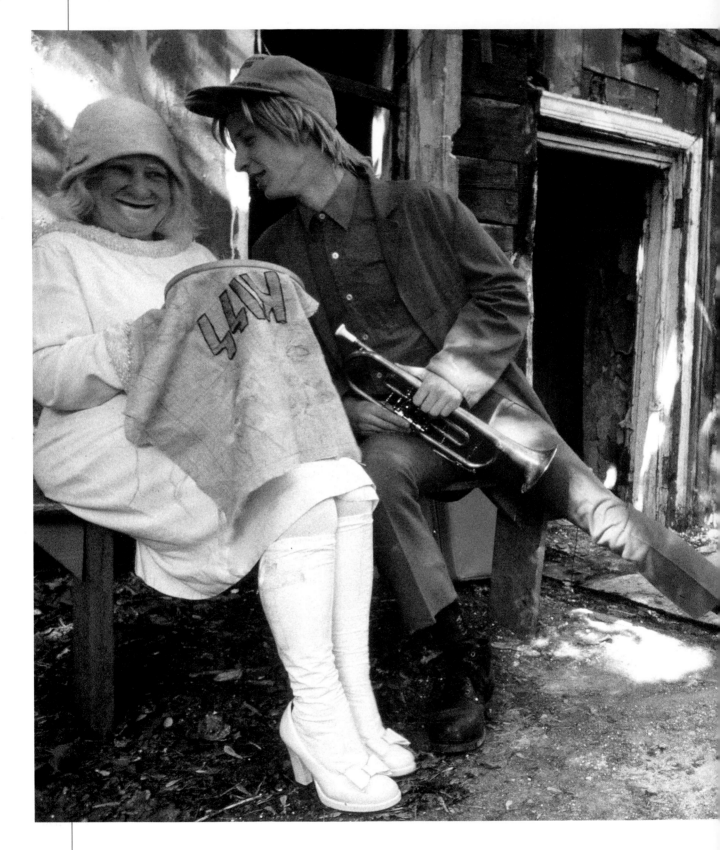

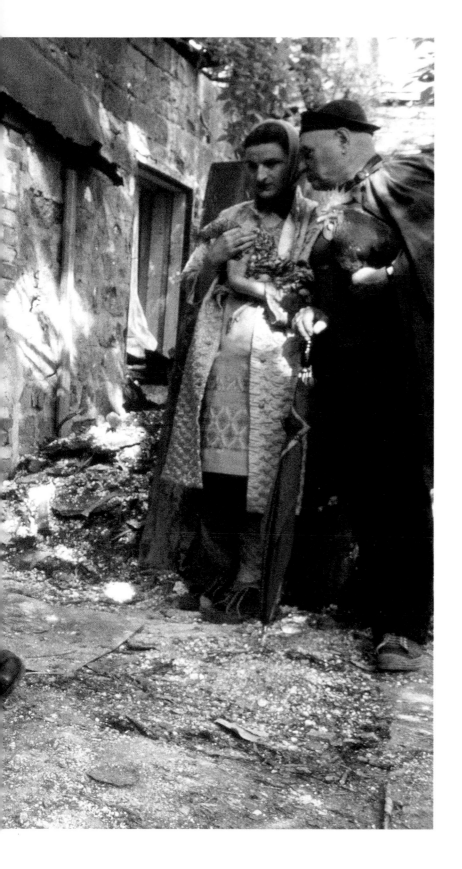

48. Alexander Petliura,
A shot from the slide
film *Snow-Maiden*,
1993

Igor Makarevich would have never had the chance to be mentioned in this book if it were not for Pepperstein, who drew my attention to the obsessive theme that had been haunting Makarevich over the whole period of his creative career. That is the theme of death, to be more precise, of the funeral. Back in 1972 he used an old daguerreotype for his triptych depicting Communards in coffins. I think the documentary presentation of this scene was of no minor importance to him. Next he produced *The Monument*, a picture showing a cross on a grave, and glued his own photograph on it, which in itself needs no comment. There were more works on the same theme. I shall describe one of them. In 1978, he needed a post-mortem plaster mask for his work *25 Remembrances of a Friend*. He made the plaster-cast from his own face, inviting an undertaker from a funeral parlour to attend at the proceedings. There is little need to say that the process of mask-making was perceived as an independent action; it was photographed and published in an art magazine. This was not the end of it, either. Makarevich produced one more work, *Transformations*, where he represented his perception of the process: how his face was covered with plaster, its stiffening and turning into a post-mortem mask, and — dematerialising and vanishing.

49. Alexander Petliura, A shot from the slide film *Snow-Maiden*, 1993

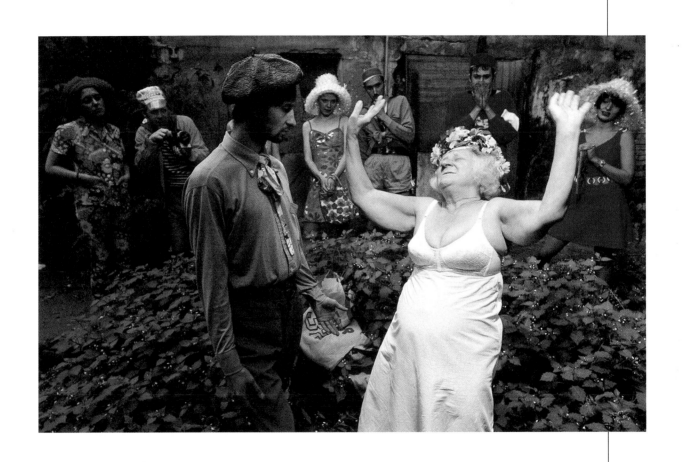

That was his last work on the theme of death, but perhaps the most impressive. Death interests him as a transitional state, as the border over which he does not want to gaze. He is enchanted by this earthly aspect of death as a certain sacral sphere where a new, higher life begins, a certain paradisiacal zone of happiness on earth, free from mundane vanity. Some funereal attributes in his later works still remind us of it.

Makarevich was not alone in his quests. The theme of Thanatos runs through the entire history of schizoid culture. Mamleyev says that the pathological fear of death lay at the core of the metaphysical searches of his peers. From its very inception this culture was wedded to Thanatos. One of the men of that epoch confessed that the presence of death was felt always: for example, you lay on the bed and death lay next to you like a lover. It was exciting: people came to look at the deceased, songs and poems were written about them, they were adored by Mamleyev's characters. (Later Sorokin would parody this necrophilic motif which, in his opinion, was a feature of all Soviet culture, and write a naturalistic story *Sashka's Love*).

The expressions 'Death is nearby', 'Death is among us' were a kind of password with the 'schizoids', the formulas of world perception. And these were no empty words. Death was a common event among them; people would leave this life as the result of some

insignificant occasion — sometimes by accident — and the number of attempted suicides were simply not counted. We can hardly understand their strange attitude to themselves and to life, in which they either could not or would not settle. They sometimes behaved as if the question of suicide had been dealt with long ago, and the act was simply postponed, but all the same, its time would come sooner or later. Once Pyatnitsky told a friend of his that they should look for stronger psychedelic substances all the time so as to sharpen their perception. His friend retorted: 'It depends on how long you are going to live.' 'I'm not going to live,' was the response.

A paradoxical thought unwittingly comes to mind, that a mental disorder was a salvatory outlet for the artists of that epoch; it helped Vladimir Yakovlev and Yevgeny Chubarov to survive, and its absence caused the untimely death of Vladimir Pyatnitsky, Alexei Paustovsky, Vladimir Kovenadsky and all those who, like them, were not so insane as to bear the burden of madness, but were not so normal as to avoid it. It was easier for those people who were not artists to protect themselves — writers, poets, translators, that is, the people dealing with words who, in the long run, had managed to build for themselves a more or less integral philosophical–religious system and shield their creative work with its protecting cover; the art that dared touch the burning truths with its bare skin had to die or change.

50. Alexander Petliura,
A shot from the slide
film *Snow-Maiden*,
1993

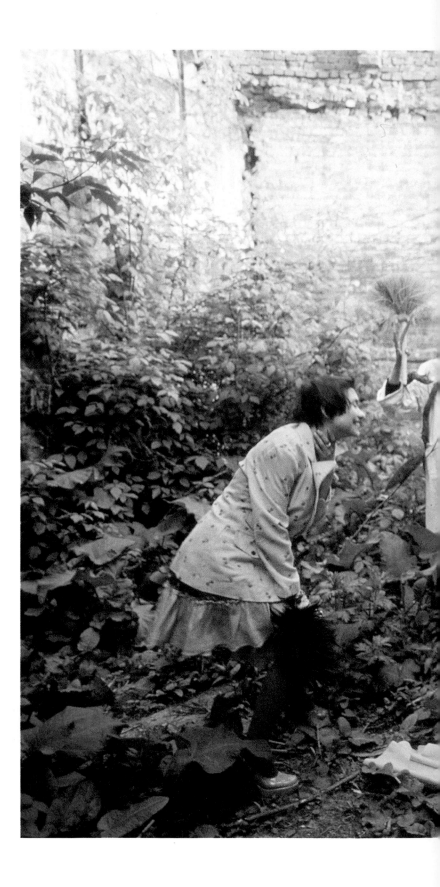

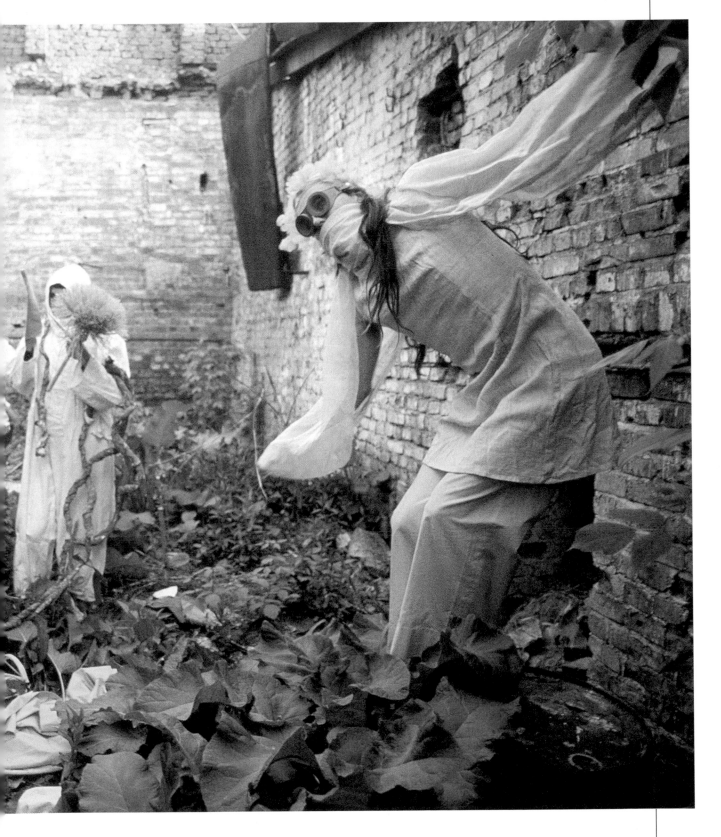

Now, when the representatives of that past epoch who outgrew their former community look at the contemporary St Petersburg Necrorealists, they exclaim with an air of slight superiority: 'They play us!'. There is some truth in this, especially if the accent is place on the word 'play'. Necrorealism emerged in the mid-1980s and was the true product of the epoch of 'stab', of mystification and hoax, which did not camouflage its jests. Necrorealism is a decorative event (this is plainly manifest in painting, and in the cinema as well); it is nothing but a style that mixed the aesthetics of black humour with the poetics of devilism. St Petersburg culture has always been distinguished by its light-mindedness, such is its spirit. Anyway, the Necrorealists at least demonstrate that they are concentrated on their subjects in compliance with the name they assumed. Moscow artists do not have even that: when Anatoly Osmolovsky steps over the conventional barrier behind which one had been within the safe limits of the notion 'subject' and demonstrates to us death in its natural form — there it is, in his hand, this horror, this dead head he has grabbed by the hair — he gives us not the smallest ground to refer this episode to the

51. Alexander Petliura, A shot from the slide film *Snow-Maiden*, 1993

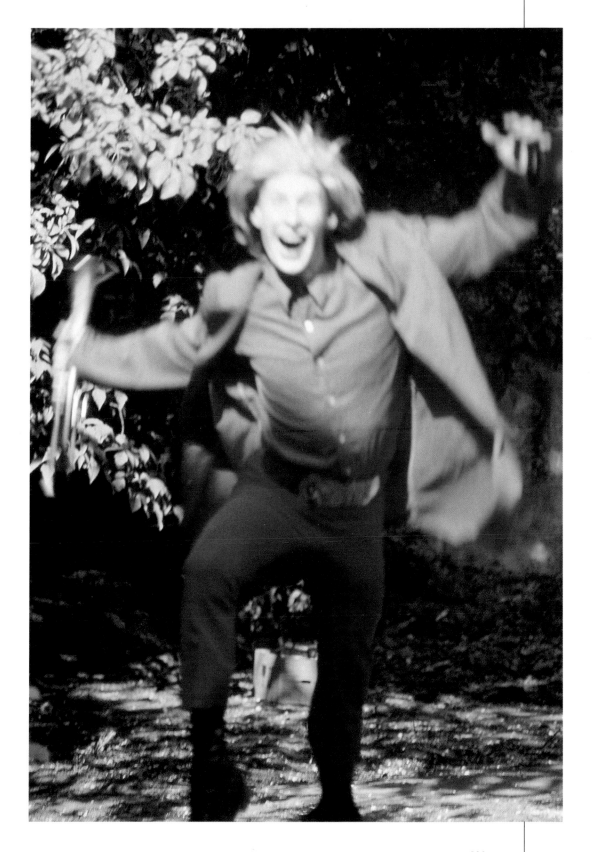

sphere of his personal impressions, to the facts of his biography or to his subconscious. His human 'self' has nothing to do with it. It would be even superfluous, as is, perhaps, the title of his work, *Chaos — My House*, because art is already well familiar with this image — it was given birth by art in its madness. The artist no longer needs to share this madness; they may only declare it, as was done by Osmolovsky, or use it without ceremony, like Alexander Petliura, who chose the seventy-year-old Pani Broni, a lady who is absolutely convinced of her blossoming youth, to be the leading actress in his theatre of costume, and even staged a ballet with her.

In bringing this story to an end, I would like to provide the final explanation. But that is impossible, for it does not fit within any of the explanations I know. One thing is certain, however, that art is ready to accept 'the truth of madness' and does not conceal its acute desire to learn it.

# NOTES

1. Georgy Ivanovich Gurdjiev, founder of a school that synthesised various Oriental esoteric teachings, primarily Sufism and Yoga. He lived in Russia in the 1910s, and later emigrated to France and opened a school in Fontainbleu. His teaching system included music, ballet, meditation techniques, and methods of achieving one's 'highest dimensions'.

2. Helena Blavatsky (b.1831, Yekaterinburg – d.1891, London). On her return from a trip to Tibet (1856), she actively promoted theosophy. She founded the Theosophical Society in New York in 1875, and published journals in India, London and New York. Her major work, *The Secret Doctrine*, in 3 volumes, was published in London (1888–1897). She lived in India from 1878 to 1884.

3. E.A. Babayan, G.V. Morozov, et al, *Izobrazitelny yazyk bolnikh shizofreniei s bredovymi i sverhtsennymi obrazovaniyami* [The Imaginative Language of Schizophrenic Patients with Hallucinative and Supervaluable Formations], Part 2, Moscow, 1985

4. Michel Foucault, *Histoire de la folie à l'âge classique*, Gallimard, 1972, p.555

5. Fyodor Sologub, (b.1863 – d.1927), Russian poet and writer, author of the novel *Melkii Bes* [Petty Demon], featuring pathologically strange characters.

6. Vladimir Sorokin, *Dorozhnoye proishestviye* [An Incident on a Trip], stories, Moscow, 1992 [citation abridged]

7. Pavel Pepperstein, *Apologia antidepresantov* [An Apology of Antidepressants], manuscript

# BIBLIOGRAPHY

Igor Dudinsky, *Chto takoye 'moskovskaya idea'* [What Does the 'Moscow Idea' Mean?], Муπеταß, Paris, 1989

Yuri Mamleyev, *The Sky Above Hell*, New York, 1980

Yuri Mamleyev, *Chatouny*, Paris, 1986

Yuri Mamleyev, *Der Mörder aus dem Nichts*, Salzburg and Vienna, 1992

Andrei Monastyrsky, 'Igor Makarevich', *A–Ya* No 3

Vladimir Sorokin, *The Queue*, London, 1988

Vladimir Sorokin, *Die Schlage*, Zurich, 1990

Vladimir Sorokin, *Les trentien amour de Marina*, Paris, 1987

Vladimir Sorokin, *Marinas dreissigste Libee*, Zurich, 1991

Vladimir Sorokin, *Die Herzen der Vier*, Zurich, 1993

# LIST OF ILLUSTRATIONS

1. Vladimir Yakovlev, *The Man Burying His Face in His Hands*, 1984, Paper, gouache, 61 x 86 cm, Private collection, Moscow, Photograph: Valentin Chertok

2. Vladimir Pyatnitsky, *Friday*, 1963, Paper, pencil, 28.5 x 20 cm, Collection: Nikolai Kotrelev, Moscow, Photograph: Valentin Chertok

3. Vladimir Kovenadsky, *Little Dragons' Play*, 1985, Gravure on paper, 23 x 15 cm, Collection: Kovenadsky family, Moscow, Photograph: Valentin Chertok

4. Vladimir Kovenadsky, *Nightmare*, 1961, Gravure on paper, 12 x 17 cm, Collection: Kovenadsky family, Moscow, Photograph: Valentin Chertok

5. Vladimir Pyatnitsky, Untitled, 1960s, Paper, pencil, 28.5 x 20 cm, Collection: Nikolai Kotrelev, Moscow, Photograph: Valentin Chertok

6. Vladimir Kovenadsky, Untitled, 1963, Gravure on paper, 15 x 10 cm, Collection: Kovenadsky family, Moscow

7. Vladimir Pyatnitsky, *Fantasy*, 1971 (Detail), Paper, ink, pen, Private collection, Moscow, Photograph: Valentin Chertok

8. Vladimir Pyatnitsky, *Fantasy* (Detail)

9. Vladimir Pyatnitsky, *Tuesday*, 1963, Paper, pen, 28.5 x 20 cm, Private collection, Moscow, Photograph: Valentin Chertok

10. Yevgeny Chubarov, From the 'Soldiering' series, 1970s, Paper, charcoal, 24 x 31 cm, Collection: Lev Melikhov, Moscow, Photograph: Lev Melikhov

11. Vladimir Pyatnitsky, *Vampires*, 1960s, 20 x 28.5 cm, Paper, ink, Collection: Nikolai Kotrelev, Moscow, Photograph: Valentin Chertok

12. Yevgeny Yufit, A shot from the film *Dad, Santa Claus is Dead*, 1991

28. Vladimir Yakovlev, *White Flower*, 1984, Paper, gouache, 59 x 84 cm, Private collection, Moscow, Photograph: Valentin Chertok

29. Vladimir Yakovlev, *Portrait*, 1976, Paper, gouache, 89.5 x 64.5 cm, Collection: Stolichny Bank, Moscow, Photograph: Valentin Chertok

30. Vladimir Yakovlev, *The Cat*, 1980s, Paper, gouache, 82 x 115 cm, Private collection, Moscow, Photograph: Valentin Chertok

31. Collective Actions group, *Performance 'M'* (Metro), 1983

32. Collective Actions group, *Performance 'M'* (Metro), 1983

33. Left: Dmitry Prigov, *Portrait of Leon Trotsky*, 1985, from the 'Bestiary' series, Paper, biro, gouache, 28.5 x 20 cm, Private collection, Moscow; Right: Dmitry Prigov, *Portrait of Mikhail Kutuzov (with Napoleon on His Shoulder)*, 1985, from the 'Bestiary' series, Paper, biro, gouache, 28.5 x 20 cm, Private collection, Moscow

34. Top: Dmitry Prigov, *Portrait of Riza Pahlavi*, 1985, from the 'Bestiary' series, Paper, biro, gouache, 28.5 x 20 cm, Private collection, Moscow; Bottom: Dmitry Prigov, *Portrait of Leonid Brezhnev*, 1985, from the 'Bestiary' series, Paper, biro, gouache, 28.5 x 20 cm, Private collection, Moscow

35. Vladimir Sorokin, Untitled, 1990, Installation, Contemporary art collection, Tsaritsyno Museum, Photograph: Valentin Chertok

36. The Medical Hermeneutics Inspection, *Polishing Little Larvas*, 1989, Photograph, text, Project for *Flash Art* No 1, 1989

37. Igor Makarevich, *Monument*, 1974, Oil on canvas, 130 x 105 cm

38. Igor Makarevich, *Transformations*, 1979, Photoprocess, Author's property, Moscow

39. Igor Makarevich, *Reincarnation of St Ignatius' Relics*, 1992, Installation. Detail, Author's property, Moscow

40. Igor Makarevich, *Reincarnation of St Ignatius' Relics*, Installation. Detail

41. Yuri Leiderman, *Sketch*, 1993, Colour photograph

42. Yuri Leiderman, *Sketch*, 1991, Colour photograph, crayon, ink

43. Yevgeny Yufit, *The Feast of Asphyxia*, 1989, Oil on canvas, 150 x 200 cm, Private collection, Moscow

44. Sergei Serp, *How Young We Were*, 1990, Oil on canvas, 153 x 196 cm, Private collection, Moscow

45. Oleg Kulik, *Piggy Gives Out Gifts*, 1992, Performance, Regina Gallery, Moscow

46. Alexander Elmar, *Thanatos*, 1993, Installation, Squat in Rozhdestvensky Boulevard, Moscow

47. Anatoly Asmolovsky, *Chaos — My House*, 1993, Colour photograph, 150 x 100 cm

48. Alexander Petliura, A shot from the slide film *Snow-Maiden*, 1993

49. Alexander Petliura, A shot from the slide film *Snow-Maiden*, 1993

50. Alexander Petliura, A shot from the slide film *Snow-Maiden*, 1993

51. Alexander Petliura, A shot from the slide film *Snow-Maiden*, 1993